Matisse

A Way of Life in the South of France

JEAN-BERNARD NAUDIN

Text

GILLES PLAZY

Recipes

COCO JOBARD

Styling

MARIE-CHRISTIANE NOURISSAT

CLAIRE DE LAVALLÉE

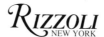

RIZZOLI
NEW YORK

Intérieur au phonographe, *Nice, 1934, private collection.*

Contents

~ ~ ~ ~ ~ ~

Introduction

Henri Matisse was born near St. Quentin in Picardy, Northern France, but spent the latter part of his life in Nice. It was in the Mediterranean sunlight of the midi that he achieved artistic maturity. It was there that he discovered the dazzling light that glorifies color and, through fauvism, embarked on one of the most formidable artistic adventures of the twentieth century.

He began to spend most of the year in Nice, and only the summer in Paris, once he had laid down the principles on which his work would be based—an almost total elimination of shadow, and free expression in a style that he was not afraid to call "decorative," contrary to the scornful position of most of the other artists of his time.

In Nice, Henri Matisse produced the most luminous, most generous, and least dramatic of painting. In spite of this he was not the happiest of men. He was concerned about the events of an era whose hopes were to fade with the rise of a new kind of barbarism. However, the moral stance which he never abandoned was aimed at keeping his own private shadows out of his painting.

Matisse always kept a low profile, was discrete about his life, his moods, his suffering, and rarely confided in anyone. He projected himself as a painter and never as a romantic character, an attitude which successfully protected him from the curiosity, idle gossip, and tall tales which are so often the lot of people of distinction.

"Henri Matisse, the man nobody knows" wrote Louis Aragon in 1942, and in fact, relatively little is known about Henri Matisse's life. The thread of his existence is difficult to follow closely—with the exception of his painting, it remains largely mysterious. No doubt this is because he was first and foremost a devoted painter (who also engaged in sculpture, drawing, and engraving, which comes to the same thing), and an extremely industrious one. Paradoxically, no other work than his offers the same celebration of life, sensuality, joie de vivre, harmony with the world, complicity with nature, in a word: delight. This is what he himself called "the savor of painting."

He lived most of the latter part of his life on the Riviera, for he loved the light and the climate, and he felt at ease in the timeless atmosphere. All around him he composed elaborate interiors, littered with his favorite objects, which became the characters in his paintings: antique armchairs, tapestries and rugs, poufs, various pottery and ceramic objects, sculptures, luxuriant plants and aviaries full of birds. He invented his own Orient inhabited by beautiful Odalisques, where his superb Russian model and faithful governess, Lydia, reigned supreme.

Nice is the place where Matisse gradually, in his successive abodes—the Hôtel Beau-Rivage, the apartment block in Charles Félix square, the Hôtel Régina, a former palace which was his last home—revealed his splendid invitation to delight.

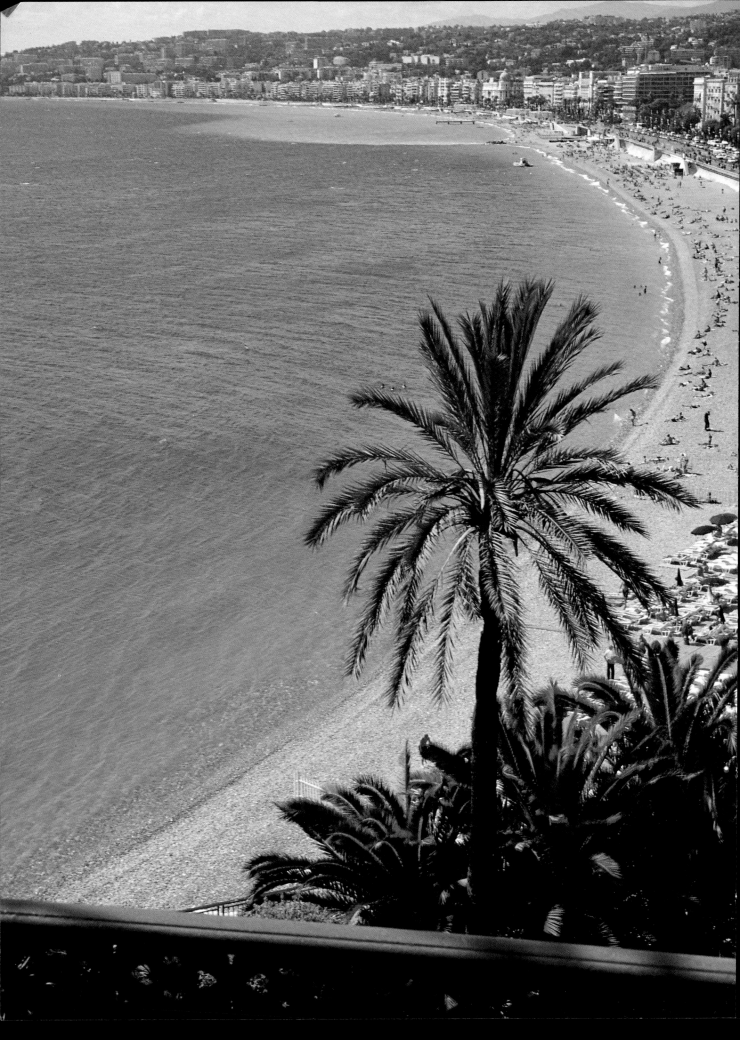

In the Light of Nice

At the end of December, 1917, Henri Matisse took a room at the Hôtel Beau Rivage at 107, quai des États Unis, in Nice. He had come from Marseille, where, in October, he stayed with Albert Marquet, his companion in fauvism. On December 16th, he was still working at the Old Port, which we know from a letter he wrote to his friend, André Rouveyre. He also went to Estaque, where Cézanne had once painted the sea, and no doubt it was there he caught a chill from the icy Mistral. His doctor advised him to go to Menton for the sake of his bronchitis, but he stopped at Nice and took a room at the Hôtel Beau Rivage. He liked it so much he decided to stay.

When he woke up on the first morning, he pulled back the curtains and looked out. The sky was overcast, but the light was nonetheless beautiful. It had something special about it that made him want to paint. Matisse contemplated the Baie des Anges. He decided to stay because the weather conditions, especially the light, were better suited to his artistic vision and method of working than the constantly changing sky near Paris. The painter repeatedly insisted on the importance of steady light conditions, so that when he was painting a model or subject, his vision would not change from one day to the next (or even from one

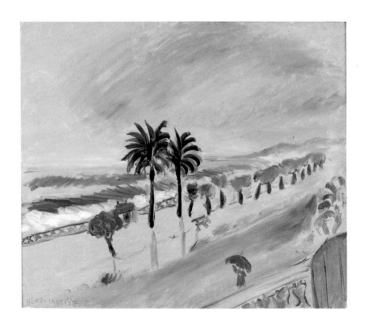

Tempête à Nice, *1920.*
Nice, Musée Matisse.

hour to the next). In 1942, during a radio interview, he stated "(…) this is because, when working on a painting, I need to remain immersed in the same sensations several days in a row, and the Riviera is the only climate I have found which allows me to do this. The climate in northern areas, especially Paris (…), is much too variable to allow me to work in this way."

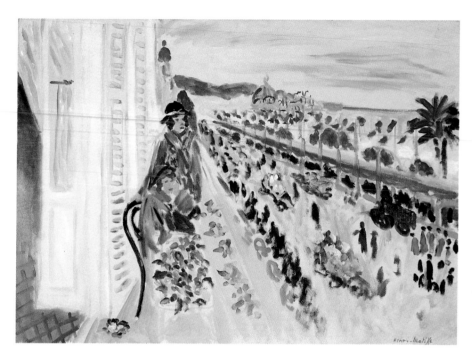

"... *The richness and silvery luminosity of the light of Nice, especially in the fine month of January, seems to be unique and indispensable to the spirit of a plastic artist," explained Matisse in 1942 during a radio interview.*

LEFT
La Fête des fleurs, *1922.*
Baltimore Museum of Art

BELOW
The palace on the jetty-promenade.

The Hôtel Beau Rivage is a modest establishment on the promenade des Anglais, near the old city, the Opera House, the Cours Saleya, and the market. It is also close to Albert-1er square and the jetty-promenade which juts out into the sea, topped by a strange Oriental-style building that houses a casino and a restaurant. Matisse had a small room overlooking the sea. It rained ("for a month!" Matisse later said about this crucial phase in his existence, no doubt exaggerating slightly.) He set up his easel and painted the view from his window, with the room itself in the background. He loved windows. He loved the transition from inside to outside that allies a room and a landscape. Then he painted a self-portrait, depicting himself as a serious, elegant, dignified man in a well-cut suit. He painted the room and the *Intérieur à la boîte à violon*. Neither the weather nor his health lent themselves particularly well to working outside, but Henri Matisse had already become an interior painter, a studio artist. He did not have the haste of the impressionists who chain the canvas to the subject, because rather than representing something, he was engaged in creat-

ing paintings, which is no mean feat. A painting is not an image, it is a new, autonomous being, which encapsulates the emotions and sensitivity of the painter and communicates them again to the spectator.

Matisse was not young when he arrived in Nice. He was forty-eight years old. Although he took up painting at a late age, when he was working as a lawyer's clerk in St. Quentin, in his native Picardy, he had already covered a lot of ground. He had even had his

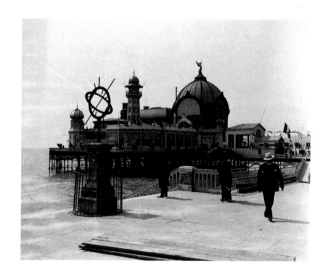

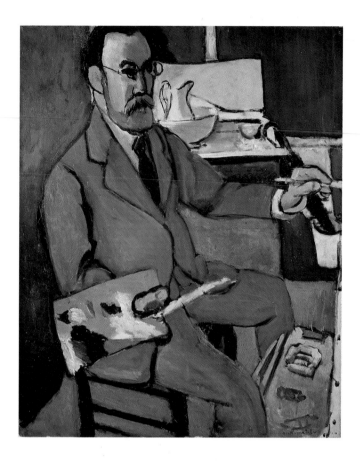

hour of glory with fauvism, the word coined at the 1907 Salon to describe the painting of those whose "wild" use of color went against all the rules of artistic etiquette controlled by the Académie and the École des Beaux Arts. He then experienced a lean period which made him doubt painting, obliged him to produce mindless work for subsistence, and forced him to return to Bohain-en-Vermandois, the village where his family lived. Amélie, his wife, was ill, and had to give up her work as a milliner. The couple had three children, and Matisse wondered if it would not be better to take up a "real" profession to make ends meet, but he held out, with the emotional support of his wife.

Impressionism was already long past, and Matisse had never really been tempted by it, even in his be-ginnings, but he still appreciated its feeling for nature, life, and light. Of all the impressionists, he preferred Cézanne, who was not really an impressionist at all but exemplified their stubborn determination, intelligence, and dedication to form. Matisse also admired Auguste Renoir, the last great representative of a generation that changed the course of painting by reconciling it with nature and flooding it with light. Renoir, whose painting is always radiant, was an old man who continued to paint at all costs, in spite of his age, his illness, and the rheumatism that caused him so much pain. He painted with his hands bandaged, when merely holding the paintbrush was sheer agony. Matisse went to see him several times at Cagnes, in his Collettes estate, a few kilometers from Nice, above Cannes. He showed him the paintings he had just completed, eager to have the opinion of his illustrious elder. Renoir was reticent, feeling that Matisse's work did not respect the sense of nuances and transition: a black line cut a motif in two. Black was anathema to the impressionists, and Renoir himself never used it. However, on reflection, he noticed that in this particular painting, black seemed to work; something transpired to make this relatively young (in relation to Renoir) painter, a real painter. Renoir told Matisse this. And he also told him there was not enough "Courbet" in it. Courbet was a master of black, and in his realism, which was more strict than that of the impressionists, he had turned black into something more than shade, even before Manet; he had made it a true color. Renoir understood that Matisse was not a disciple of impressionism and sensed that he was only at the beginning of his own artistic journey. So, if he was not an impressionist, he should embark with more authority in the opposite direction, where lines cut through forms, and where black can itself be a form.

France was at war, and Paris was too close to the front. Matisse wanted to paint in peace. He wanted to do his duty with regard to the war and, since he was

chose to work in the Riviera light. He first discovered the Mediterranean in February 1898, on his honeymoon with Amélie, just after a visit to London to see William Turner's paintings and watercolors. His wife's sister was a primary-school teacher in Corsica, and they took advantage of this to visit the island in the springtime. "The paintings brought back from Ajaccio, then Toulouse (...) are striking in their iridescent light and color," wrote Marcelin Pleynet. These paintings were astonishing from an artist influenced by Cézanne, which prompted the Belgian painter Henri Evenepoël to say that his friend Henri Matisse was the representative of an "epileptic, mad impressionism."

Amélie's parents were in Toulouse, where the newlyweds spent the following summer. At the Salon des Indépendants, in June, Matisse had been greatly moved by Monet's exhibition and the paintings of

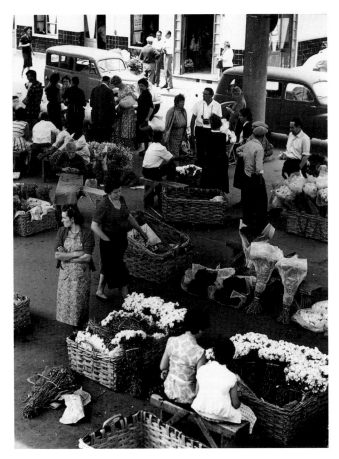

too old to be drafted, he asked the government minister, Marcel Sembat, who was a knowledgeable art lover, to employ him in serving his country. The answer he received was that the best thing he could do to serve France in these times of war was to paint! So he painted, and gradually felt his goal to be within his reach: a new kind of painting that did not simply represent what the artist saw, but that recreated it in a new form, that of a painting. Matisse was not content to create the most beautiful, true, and personal images, as Courbet and the realists, Renoir and the impressionists, Cézanne and Signac all tried to do. These were painters from whom he had learnt so much, but they did not address the question that was Matisse's main preoccupation: how could he give form to a subject and paint the emotion it aroused in him without betraying the subject itself?

Like Renoir and Courbet before him, Matisse

Signac, who tried to extract from impressionism a systematic theory of color and light. That year, from the Corsican winter to summer in Toulouse, Matisse had been overwhelmed by the light of the South of France, which cancels out the contrast of light and shade and allows color to bloom. He had come to painting through the Flemish influence and took art classes at a time when impressionism was becoming academic. But he also studied closely the paintings of Vincent Van Gogh and Paul Gauguin, who handled color with a new-found freedom, giving it its full expressive value, at the risk of moving away somewhat from realist tones.

The Mediterranean held a further shock in store for Matisse, in 1904. Signac invited Matisse to his house in the pretty little fishing village of St. Tropez. The master of divisionism believed he had found a disciple. Matisse did, in fact, paint hieratic scenes with small dots, and produced a masterpiece of post-impressionism, his first major decorative composition, entitled *Luxe, calme et volupté* (1905). The next two summers Matisse spent in another small Mediterranean fishing port much admired by Signac, called Collioure, at the foot of the Pyrénées. He was joined there by Derain, and together they conceived what was to be known as fauvism.

Between two stays at Collioure, and after spending five months on *Le Bonheur de vivre*, a large, decorative painting which is a continuation of *Luxe, calme et volupté*, and whose very title could be applied to his work as a whole, Matisse went to Algeria. He brought back some pieces of pottery which inspired him to

Nature morte, monotype, *1916.*
Private collection.

work on ceramics, and which he used in several still lifes. It was also at this time that he discovered Negro art and understood what he could take from it for his own artistic purposes (*Nu Bleu* and the sculpture *Nu Couché I*). He was now sure that he could associate expression with decoration, and that color would allow him to do it, which he demonstrated in 1909–10 by painting the dazzling *Danse*, for the Russian collector Chtchoukine.

Then there was Spain, too, in 1910, where he went alone in search of pottery, after a trip to Munich with Albert Marquet to see an exhibition on Islamic art. Haunted by insomnia, he nonetheless brought back some beautiful still lifes and an imposing Spanish lady, which is a tribute to Manet. And there was Tangiers, twice, in the footsteps of Eugène Delacroix. Guillaume Apollinaire was able to recognize then what already was Matisse's singularity and strength, and he gave a good definition of what, to the very end, would be the key to his work: "Matisse is one of the rare artists who freed himself completely from impressionism. He does not strive to imitate nature, but rather to express what he sees and what he feels in the very substance of the painting, like a poet uses words from the dictionary to express the same nature and the same feelings." (*Chroniques d'art*) At this time, Matisse had already stopped painting images as more-or-less objective representations of reality; he painted paintings, that is to say plastic works of art in which the subject (the first thing seen) is transformed, reconstituted in order to become the very substance of the (act of) painting, shapes and colors recomposed in a new unity. Matisse

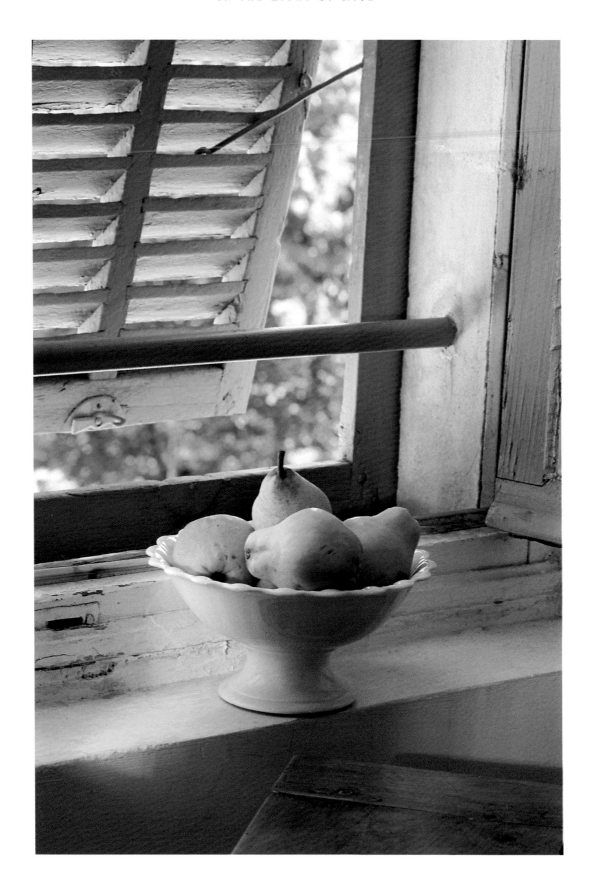

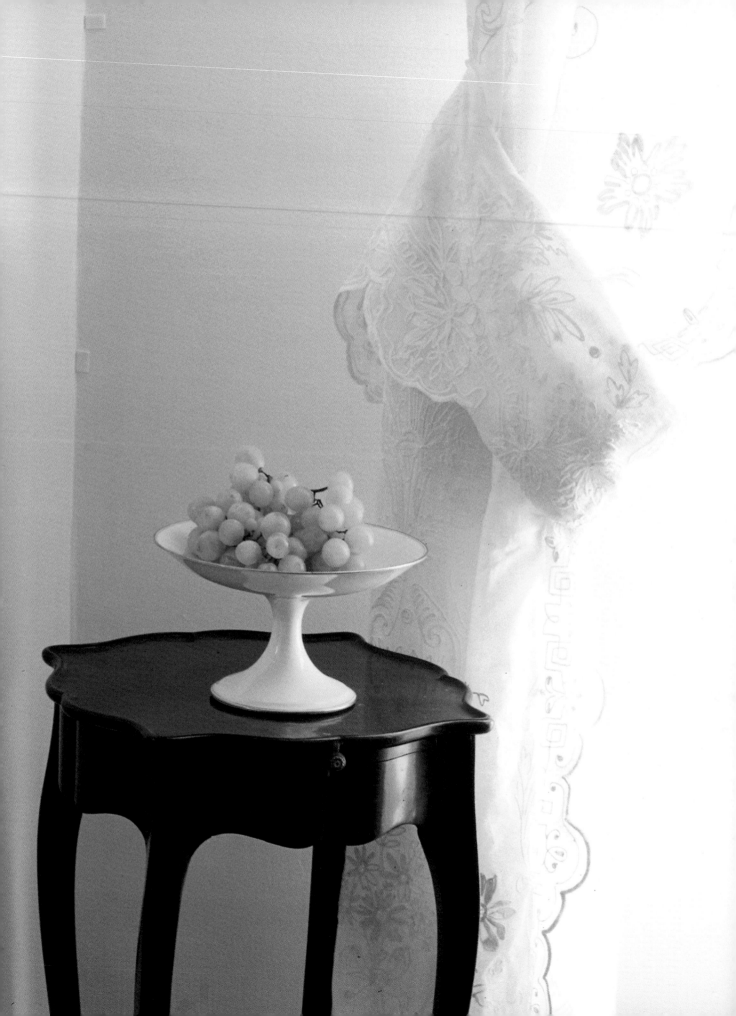

It was the light that held Matisse in the South of France. The Mediterranean was coming into fashion, attracting painters in the footsteps of Cézanne, Van Gogh, and Signac. But Matisse's light in Nice was that which entered into the bright rooms, often filtered by the curtains and louvred shutters.

"Where does the charm of your paintings of open windows come from?" Matisse would be asked. And he answered: "It is probably because for me it is a single space from the horizon to the inside of my studio, and the passing boat lives in the same space as the familiar objects around me, and the wall of the window does not create two different worlds."

RIGHT
La Sieste, intérieur à Nice,
1922. Paris, Musée National d'Art Moderne.

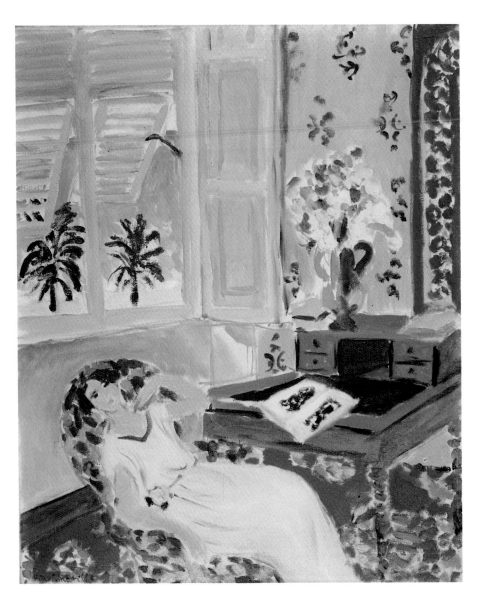

was by now a truly great artist, original and unique, and no longer part of any artistic school. He had just painted masterpieces such as *Les Marocains*, an astonishingly constructed canvas in memory of Tangiers, on the boundary of abstract art, mysterious and serene, hieratic and dreamlike.

Matisse stayed in Nice the winter of January 1918. He imposed a strict discipline on himself, with precise working hours. In the morning, he worked in his studio, then went out for a "frugal lunch in a crémerie" (Georges Besson) and allowed himself to linger under the parasol of a street café for an hour or so. In Paris, art dealer Paul Guillaume was exhibiting Matisse's paintings in his gallery, along with the paintings of a highly esteemed rival, Pablo Picasso, who had launched cubism tangentially to fauvism and placed it slightly in the shade. Guillaume Apollinaire, who was still in the army, wrote a text for each of them, making the orange, that sunshine fruit, Matisse's symbol. The art critic Louis Vauxcelles, who was under Matisse's charm, exclaimed: "Such a strange and profound artist, the most gifted, the most sensitive of them all." From

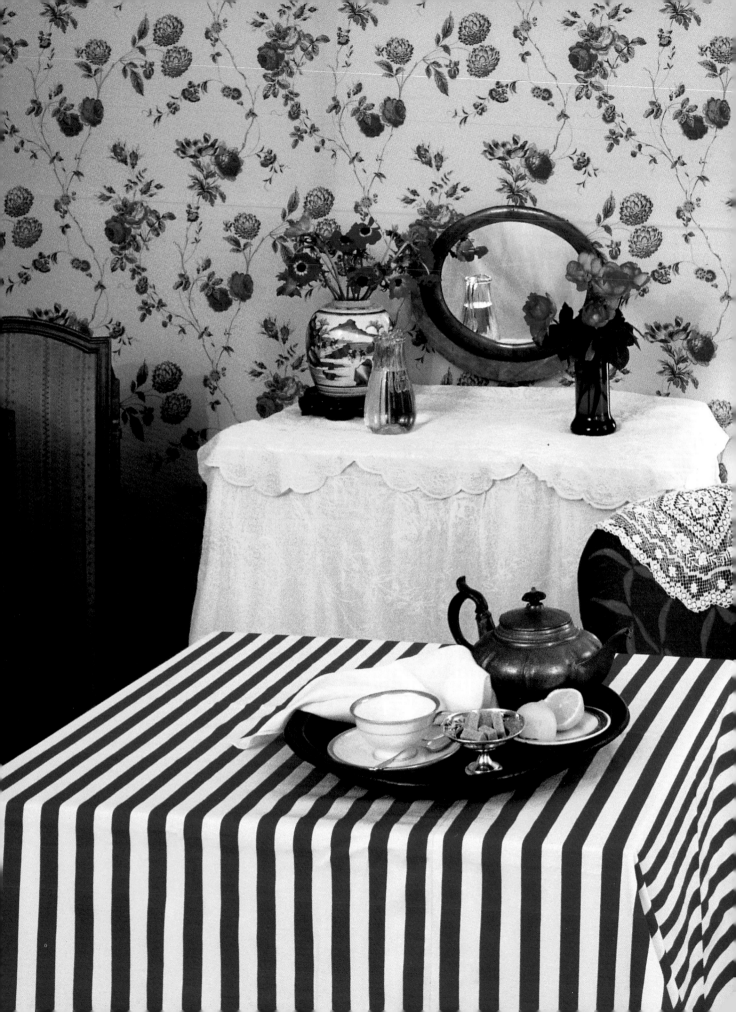

February to April, Matisse rented a studio at 105, rue du Midi, right next to the Hôtel Beau Rivage. He frequented the École des Arts Décoratifs, where the teacher was Gustave Moreau, who had also frequented the Parisian atelier. And so he was able to work with live models and try to understand the intrinsic magic of *La Nuit* and *Laurent de Medicis* by Michelangelo, whose moldings he copied in drawings and in plaster models. As for his personal models . . .

Amélie came to see him for a while. Then Marguerite and Pierre, his eldest son. He did several portraits of his daughter on the balcony of the studio before she went back to Paris. He had his son pose with his back to him, against the light, in a very poetic painting called *Le Violoniste devant la fenêtre*. He took it with him when the Hôtel Beau Rivage was requisitioned by the army, and he had to leave and move into a villa at 138, boulevard du Mont-Boron. From time to time he left Nice to paint landscapes, at the col de Villefranche, for example. He also painted in the gardens of the château. He loved olive and eucalyptus trees. He painted flowers and was ecstatic when, after a week of rain, the trees in full bloom exhaled their fragrance.

The war broke up the family. The three children were almost adults. Both sons were old enough to join the army. Matisse, in the name of painting, became independent and instituted a new lifestyle in Nice: the

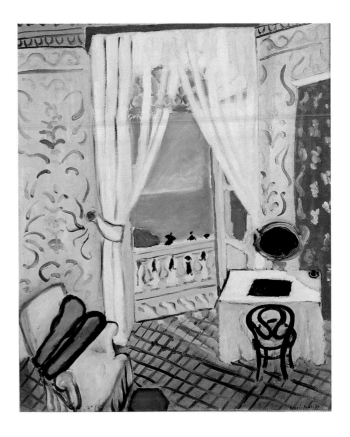

ABOVE
Intérieur à la boîte à violon, *1918–19.*

New York, Musuem of Modern Art.

BELOW
Le Nu étoilé, *1921–22.*

Private collection.

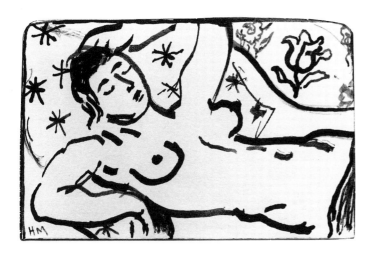

family, from then on, would be seen mainly in summer, when he returned to Issy-les-Moulineaux or to the apartment he was soon to acquire in Paris, on Boulevard Montparnasse. The war also destroyed his native town and the village in which he spent his childhood. He was by now almost fifty years old, and was entering a new era. In April 1918, while Marguerite and Pierre were staying with him, he wrote to Charles Camoin: "It's very pleasant, but still, I do work better when I'm alone."

From that time on, he remained faithful to Nice. He returned in autumn, and stayed at the Hôtel de la Méditerranée et de la Côte d'Azur (25, promenade des Anglais). He liked its pretty, Italian-style ceiling, and

the tiles and blinds. The hotel was not far from the Hôtel Beau Rivage, but it was more comfortable, although nothing like the luxurious palaces for which Nice is famous, which attract princes and pashas. The rooms had large windows overlooking the Baie des Anges and were decorated in nineteenth-century Italian style (at that time Nice was in fact Italian) which the artist rather liked, as he had always been keen on the decorative arts. Matisse was happy there: unlike most of his colleagues, he did not like to paint in a cold, neutral, typical artist's studio. Neither did he seek out zenith light, or a north-facing bay window through which only a restricted light could enter. There he was, facing directly south above a wide avenue overlooking the sea, able to look out over the scenery or turn around toward the inside, concentrating on the work from which nothing could distract him. Matisse re-

turned to Nice in the autumn of 1918, and he would do the same every autumn from then on: he became Niçois. Francis Carco was his neighbor in this hotel, and when Matisse met up with him again in 1941, during the Second World War, he asked him "do you remember the light we had through the shutters? It came from below as if from the stage of a theater. Everything about it was false, absurd, wonderful, delicious."

In Nice, Matisse soon got out of the habit of copying nature. Painting in the open air had become fashionable in the nineteenth century and virtually became the mark of impressionism, a movement that was enthusiastic about landscapes and natural light, and was only practiced indoors as a last resort. If the painter remains in his studio and the studio is lit by light from a window, a door, a stained glass window, this is already an artifice that takes the natural away from the real. After fauvism was over, Matisse was essentially an interior painter, an indoors man who went out little, rarely walking or traveling (although occasionally he would walk briskly to calm himself down), attached to his work and no longer taking his easel out into the fields. Far from an impressionist, he did not trust immediate perceptions, or the swift reaction of the artist who is in a hurry to capture the moment. He needed time, time to allow impressions to mature, to allow the images assimilated to transform, fade into the subconscious and then return, ready to enrich the painting. When inside, however, he did not cut himself off completely from the outside. The windows were wide open and, when the artist maintained a certain distance from it, the landscape became a painting within the painting, a landscape cut out of the decoration of a wall. The window marks the distance, separates the painter from the subject as much as it frames it. He was not a part of the landscape the way a good impressionist was, but Matisse would always say he was constantly aware of the entire space. The presence of a window situates the artist: at a distance, inside, in the

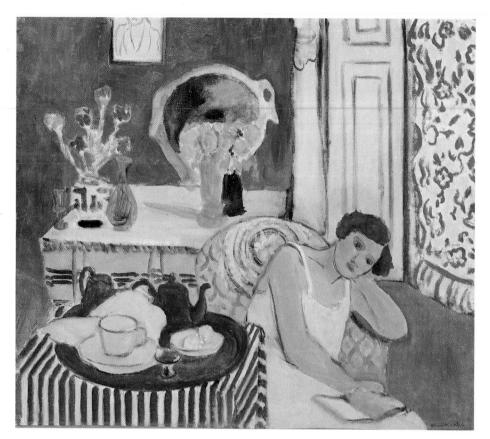

There was no painter more haunted by the figure than Matisse, who was fascinated by the body and the presence of the women he used as models. Matisse was a painter seduced by his subject.

LEFT
Le Petit Déjeuner, *1921.*
Philadelphia Museum of Art.

studio. And the landscape painted in this way is never an invitation to travel, no more than it is the medium for some daydream: simple, uninhabited, strictly formal, it is not depicted in any way as an object of desire.

Matisse was least of all a landscape artist. He spoke as little about the Riviera as he painted or even drew it. In the end, it was only decor, there outside the window, whose only purpose was to allow bright light, external, implacable light to erupt into the studio, its soft rays exalting the subject, the human figure. Above all, for Matisse, was the human figure; he asserted that for him it was the major factor. In 1920, he painted a strange *Tempête à Nice,* observed from his window. In the foreground, a part of the railing on the balcony of the Hôtel de la Méditerranée is visible, and beyond is the sea rolling onto the beach. Two high palm trees stand erect, seemingly unaffected by the excessive meteorological conditions. The painting was produced

with the rough, hurried brushstrokes of fauvism, and it is clearly a regression in relation to the contemporaneous paintings, which were based on a celebration of line and solid, flat color. Some time later, he painted a *Bataille des Fleurs,* which also did not fit in with the predominant style he had developed. Paintings like this seem to have been painted for recreational purposes, a re-emergence of the naturalist streak of fauvism. Or quite simply, Matisse took pleasure from time to time in "natural" exercises like this in which he allowed himself to be more spontaneous than he would be ordinarily.

Matisse had already been opening windows in his paintings for several years. For example, in *La Conversation* (1910–11), he painted himself with his wife, each of them on either side of a window looking out on their garden at Issy-Les-Moulineaux. Pierre Schneider attributes to this painting the importance of a sacred work, which stages the dilemma of all artists, caught

between the imperatives of ordinary life (spouse, family) and the call of art, here represented by a garden framed in a window like a painting on the wall. Matisse may have boasted to an American journalist, Miss MacChesney, that he was just an ordinary father; the truth is he was completely devoted to painting and now, here in Nice, in the absence of his family which stayed in Paris over the winter, and of his wife who only visited him rarely, he gave himself to it entirely.

The lack of depth of the landscapes that appear in the windows of Matisse's interiors often gives them that air of a painting within a painting, or at least lends them a disturbing ambiguity: we can clearly see that they are landscapes glimpsed through open windows, but there is an unreality about them, and it is therefore difficult to decide whether they open out the room or define its limits with a final false plane. So the land-

scape becomes an element of the decoration of the room, a projection onto the back wall. The important thing is not the landscape, but the interior capable of integrating the exterior into itself. And why not see in this a metaphor that this artist is both sensually turned toward the outside and introspectively turned back into himself, absorbing all the outside information?

The very beautiful *Intérieur à la boîte à violon* of 1918 is composed of an astonishing layering of three openings which draw a perspective in two obliques, from the foreground with a violin case, to a second plane with a half-open window, then to a third plane with a jalousie raised on a blue sky which dominates the top of a palm tree. Inside, black is predominant, on the floor and on the walls. In all this black a blue patch surprises, like a clear blue sky inside the case, a case which opens like a window. The violin belongs to Matisse, who, like Ingres, was a practicing musician. Perhaps the violin case here stands for Matisse himself, the artist who, in the obscurity to which human life seems destined, struggles for the blue of the sky, to achieve painting that is harmony and serenity, to create a melody. However, the blue of the violin case is opaque, which poses the question of whether a window really has to be open or closed. Matisse's windows only seem to be open, they only open onto representations of landscapes, onto paintings, onto painting itself, like the violin case which shows raw blue, making painting the equivalent of music. This patch of blue, which we would like to push to a symbolic interpretation, attracts the eye to the foreground of the painting and prevents it from escaping through a window which is not quite as open as it appears.

Matisse, as we were saying, played the violin and he played it well. He could perhaps have earned a living at it if necessary, by busking. He thought about it at times, when his painting career was not going well. He also thought about it when he was worried about losing his sight, a common occurrence with painters.

He played a lot during his first years in Nice. He later gave it up, finding that it took up too much of the energy that he needed for his painting. He still appreciated music though, and often played his gramophone, went to concerts, listened to the radio when it broadcast classical music during the night, when his insomnia kept him awake.

It is true that there was still a little landscape present in his painting, but it was hurried and instinctive (*Paysage, Nice*, 1918), a few tiled roofs behind some trees under an ill-defined sky, or even sketched, as with the rough drawing of his daughter, Marguerite, on the rocks (1920), or it was genre painting, in *Conversation sous les oliviers*, which somewhat awkwardly depicts two brunettes with red flowers in their hair.

Antoinette Arnoux was the first Provençal model whose name is known to us. Matisse wrote to his friend Camoin; "(she is) a tall sixteen-year-old, a colos-

sus of a woman, with breasts like two-liter bottles of chianti!" She came into Matisse's painting after Lorette, another brunette of whom Matisse painted several portraits in Paris. He produced about fifty drawings of this "passive nudity" (Marcelin Pleynet) and he made her an Italian straw hat decorated with ostrich feathers and ribbons falling in curls from both sides. It was an original hat which could be worn back-to-front, and Matisse painted his model wearing it. He needed the emotion aroused by eye contact, the presence of a live model. Imagination was not sufficient for Matisse. Neither were memories. He needed to be physically attracted to his model, whether he was painting a person or an object. He did not paint many men; nor did he draw them, for he was more interested in feminine charms. However, most often he dressed up the faces and bodies of these young women, set the scene for them. Was it because he was born in the north, where

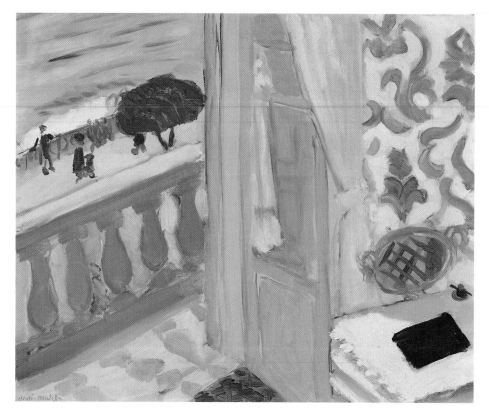

Matisse was an interior artist, scarcely interested in landscapes. He did not scour the countryside with his easel. He remained home, in the setting he composed, which was as much the subject as it was the frame of his painting.

LEFT
Intérieur au cahier noir,
1919. Zurich, private collection.

weaving and embroidery are so important, that he had such a keen sense of the beauty of fabrics and dress-making? He never ceased to cultivate his taste for them.

Matisse drew nudes more often than he painted them, because he loved to contemplate the female body and, as an artist, observe and admire it. He had to be familiar with the body, how it moved and its solidity in order to paint it clothed, so that the body's presence was discernible under the clothes, and did not give the impression of a tailor's dummy. To create a painting, though, he had to marry the form (the model or subject) and the substance in a unity of composition where the lines and colors echoed each other in the painting space. The fabric of a dress echoed that of a tapestry, the pattern on wallpaper, or a rug.

Matisse became attached to his models. He did not paint just anybody. The model had to be beautiful, but with an expressive kind of beauty, and a presence. When he found a model, he looked at her, drew her,

and painted her until he exhausted the source of inspiration. Antoinette Arnoux was indispensable enough to Matisse for him to take her to Issy-les-Moulineaux in the summer, where he introduced her to his daughter, to his wife, and to the dog, Lily, who scratched her head, apparently perplexed (*Le Thé dans un jardin*).

His second year at the Hôtel de la Méditerranée et de la Côte d'Azur, Matisse had a different room, with ordinary windows enhanced by a pretty wrought-iron balcony, with long curtains and shutters to filter the light. Another model, perhaps Antoinette's sister, posed for Matisse against the light, in an armchair. Before he went to Nice that year, Matisse went to London to work on a project which was a new experience for him, although some years earlier he had he been involved in a similar adventure when he painted the large panel called *La Danse*. Diaghilev, the famous choreographer from the Ballets Russes, who later worked for the Monte-Carlo ballet, asked Matisse to

Jeune Fille au livre sur les
genoux, *1918. Private collection.*

create a curtain for *Le Chant du Rossignol.* Matisse could have designed a small-scale model, to be enlarged by other artists, which was common practice. But no—he had to work to scale in a studio adapted for the purpose under the rafters at Covent Garden. He had prepared the work by producing numerous sketches for the costumes and décor in the previous months in Nice and at Issy-les-Moulineaux. But he was not one to take such a task lightly, and he stayed in London at least a month; the trials and errors were such that he even told Diaghilev he couldn't do it. Then, all at once, he did it with brio—all the while maintaining that he would never be able to do it.

The following year, after spending some time at Étretat with Marguerite, he found a large room with a balcony overlooking the Baie des Anges, with French windows, highly-patterned wallpaper and, as always, one of the vanity tables with round or oval mirrors whose forms and reflections he liked to use in his paintings. The poet Charles Vildrac, who came to see him in 1922, was astonished by the modest size of the room. No doubt he had been impressed by an image of *La Danse* painted for Moscow, and he expected to find Matisse in a room as large as a ballroom. He was also surprised by the fact that each object in the room (the table, the armchair, the porcelain vase, ornaments, etc.) all seemed to be in the place best suited to their shape, size, and color, where the light showed them to their best advantage.

A new model then appeared in Matisse's studio, in his painting, and in his life. Henriette Darricarrère was also from the north of France, since she was born in Dunkirk, but her parents had moved to Nice. She was a beautiful young woman, attractive and elegant. She played piano, violin, painted, and more importantly, she danced. Matisse found her at the Victorine studios, where, at the beginning of the century, Nice gave itself Hollywood-style aspirations. Matisse quickly understood that this was a useful source of pretty women who were often poor and therefore amenable to making ends meet by posing for an artist. Henriette became his main model from 1920 to 1927. She had a stronger personality and more presence than Lorette or Antoinette, who had preceded her in the studio of this artist who was "obsessed by the human figure," by the female body, which aroused more emotions and presented more difficulties than any other subject.

A photograph taken by Man Ray shows Henriette reading, seated at a round table. Placed in front of her is a large bouquet of flowers in an octagonal vase, and a large mirror and a tapestry make up the background. She is wearing a skirt with vertical stripes, a scalloped

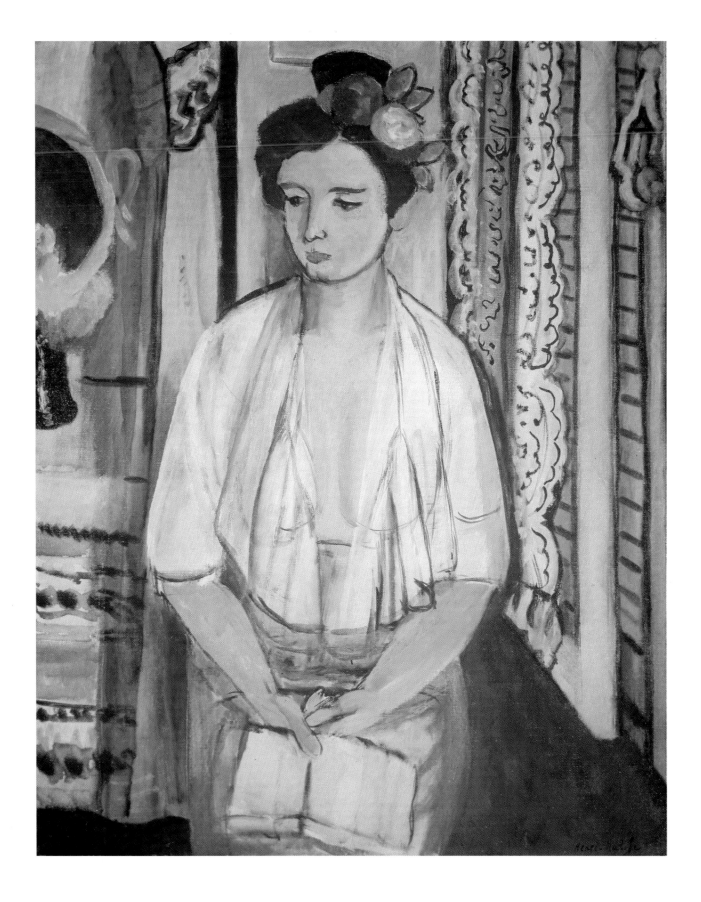

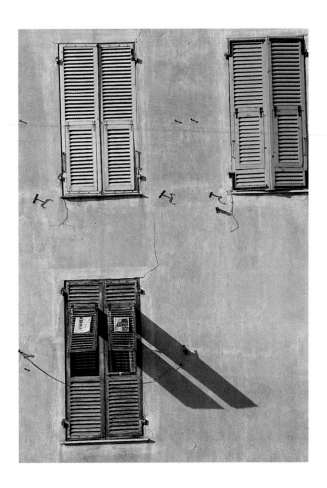

blouse, and sneakers. She has a dark ribbon across her forehead. She is leaning slightly forward, with her left elbow on the table, her right arm falling onto her thigh. She looks just like a Matisse painting, like the model for a Matisse painting. Matisse drew her and painted her, in the studio, on the balcony, with Marguerite when she came to visit. He took them to the country in his automobile to picnic on the heights of Cimiez and in the gorges du Loup. As Cézanne would have done, he carefully placed the figures in the landscape. And when the *bataille des fleurs* passed along the promenade des Anglais, under his window, he painted them as they watched, against the light, otherwise they would not have been able to hold the same pose. He later said that he did not like that annual clamor, but the fact remains that he painted that astonishing spectacle of a town in celebration and that, even after he left the hotel to live in an apartment, he went to the trouble of renting a room at the Hôtel de la Méditerranée to have the same vantage point as in previous years.

LEFT
Nice, persienne, palmier, banc, *1917–18.*
Paris, Musée National d'Art Moderne.

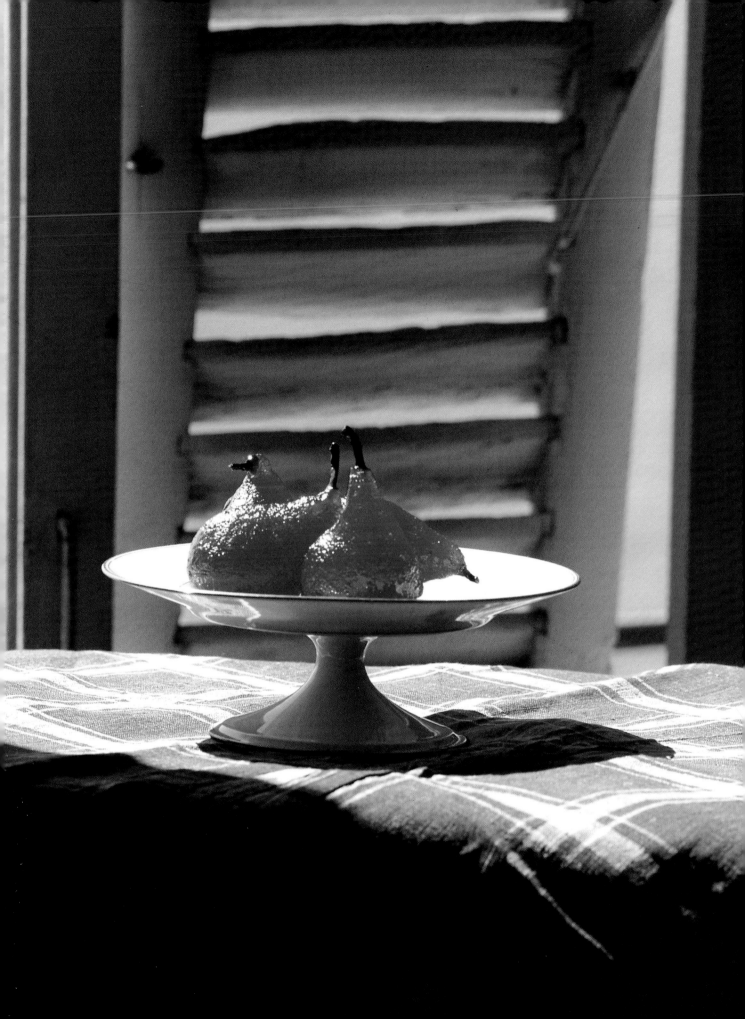

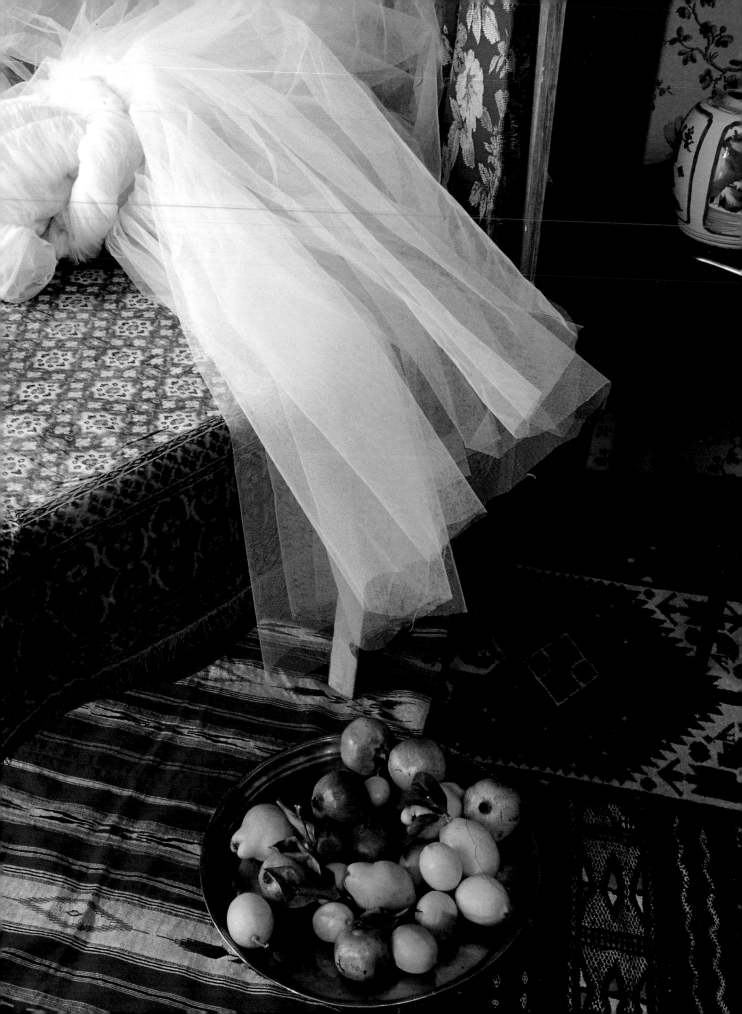

The Days of Odalisques

In autumn of 1921, on returning from a second stay in Étretat, Matisse decided to improve his living arrangements in Nice—that is, he would stay there, give up living in a hotel room, and take an apartment in which he would be more at ease both living and working. According to Francis Carco, Frank Harris, a literary Englishman who had defended Oscar Wilde against British hypocrisy, allowed the painter, whom he admired, to have an apartment on the third floor of a handsome eighteenth-century building. This square, ochre, Italian-style mansion once belonged to Count Eugène Caïs de Pierlas, a prominent member of the nobility in Nice.

The address was 1, Place Charles-Félix, in the old city, facing the sea. The apartment had a clear panorama to the south and west, and a view of the promenade des Anglais, the escalier Lesage. The chapelle des Pénitents, actually the chapel of the fishermen, was a short distance away. The morning clamor of the neighboring market reached the windows, made up of the melodious voices of the local population, who were known for their vociferous expression. Matisse had a large studio with a fireplace, a painted ceiling, and wallpaper with a bizarre, gaudy pattern. On the walls he hung a few paintings from his collection, some

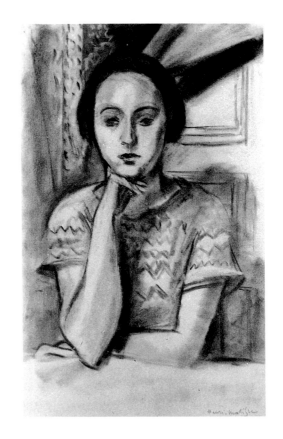

Matisse furnished his new studio with various fabrics, drapes, and rugs, creating for his models, and especially for Henriette, a real setting.

ABOVE
Henriette, *1922.*
Paris, Fondation Dina Vierny– Musée Maillol.

43

African masks, a few of his own works and, true to form, a large mirror. He also installed a sort of small, portable theater, composed of a low podium and wooden frames which allowed him to arrange the drapes he so liked to use as a background. Photos of the era show how he set up this studio decor using various fabrics, drapes, and rugs. For each painting he created a new frame, within which he placed his model as if in a chest—especially Henriette, who was dreamy and seductive as an odalisque. It is true that Matisse, who was born in Cateau-Cambrésis, in textile country,

BELOW
Nice, the Place Charles-Félix fruit-and-vegetable market.

OPPOSITE AND OVERLEAF
From 1921 to 1958 Matisse resided in this handsome eighteenth-century building.

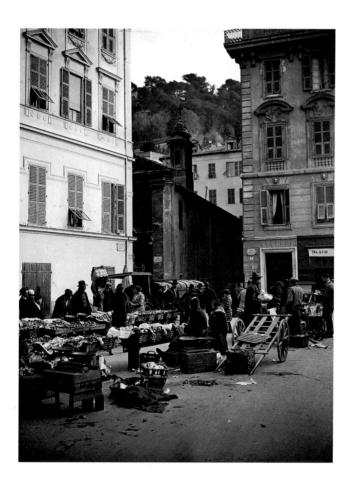

took his first art lessons in a school for textile design, although he realized his vocation was to be an artist while he was working in a law firm.

Matisse had another, smaller studio for sculpture, where he continued to work regularly. He used sculpture to tackle the problems of substance and volume, and to enrich his painting through a different experience, but also simply for variety: he worked all day long, and apart from a few short walks, he allowed himself little leisure time.

"At Nice, during the 1920s" wrote Pierre Schneider, "the exotic interiors where Matisse was at ease were simply disguised studios." Everything in Matisse's living space was organized for work, less for the pleasure of living than for the celebration of art, which is an essential component of Matisse's work. He therefore lived in a transformable setting, surrounded by a variety of objects, pots, vases, pottery, statuettes, armchairs, poufs, cushions, fabrics, plants, which were there to compose an environment favorable to his artistic imagination, by inciting different images, new alliances of shapes and colors. It was also a store of accessories from which he could choose to add to a subject. For Matisse, the studio was not just a place for work. It was the place where he spent the best part of his life, a place that he arranged so that the energy he required was constantly present. The studio is not a passive space in which one is at ease to concentrate, it is an active space which fuels the imagination and artistic sensitivity. Just as Monet tended his garden, and practically became a horticulturist in order to paint Giverny the way he wanted it, Matisse composed his studio to paint it, and to paint in it.

In 1896, at 19, boulevard Saint-Michel in Paris, from which Matisse painted the Saint-Michel bridge and Notre Dame, his studio was already, according to the reports of people who visited him there, abundantly decorated with cloth, rugs, and ornaments. In 1901, he made a painting of his studio at Issy-les-Moulineaux,

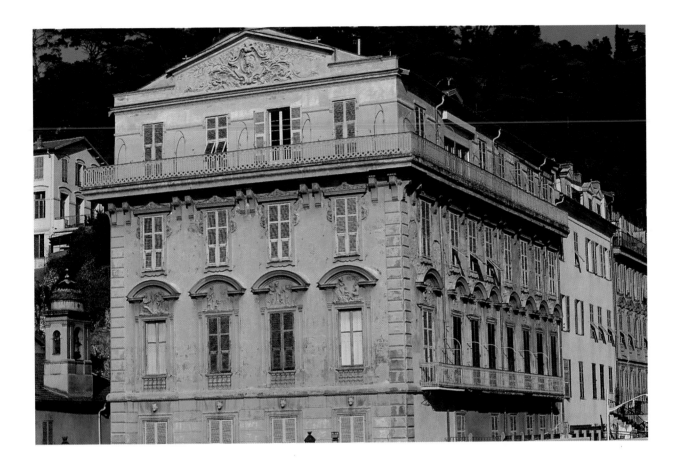

L'Atelier Rose (The Pink Studio). This painting already showed how a certain idea of the studio and a certain idea of painting itself could coincide—how to move between the real space in which he lived and worked and the fictional space of the painting. The painting, which was two-dimensional, did not merely represent space according to the projective method which makes it possible to give the most objective representation of depth by obeying the laws of perspective. A painting can not be reduced to an image. In the studio which was the subject of the painting of 1901, there was a rug, a screen on which was draped a piece of fabric with a large pattern, which was the background for a piece of pottery sitting on a stool, paintings on the wall, a sculpture, etc. A classical, academic painter would have encapsulated the whole from a central viewpoint and indicated distances by balancing the proportions. Cézanne, who broke with this graphic usage, painted space differently. In his landscapes and still lifes, he tried to give the impression of the thickness of the air, showing how the rays of colored light emanating from each object contributed to the perceptible reality of the space and created a sort of magnetic relationship between the various elements of the subject. Matisse, by allowing the full intensity of color and contrasts to express themselves, which he did as early on as the fauvist period, could not follow in the footsteps of Cézanne and had to resolve the spatial representation issue in a new way. This is what he had already started to do in *L'Atelier Rose* by creating a harmonious atmosphere through the strength of a dominant color, and by bathing the studio in a wash (more red than pink, to tell the truth) which creates resonance between the different elements of the painting.

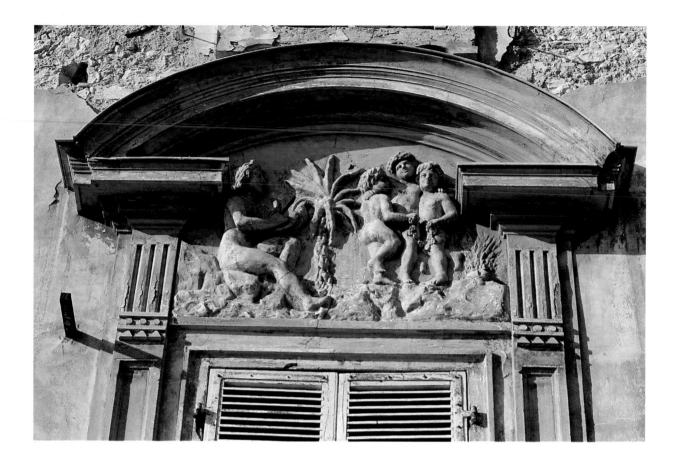

Then he took up the theme again and gave it further impetus by giving even more importance and violence to the red, which eventually pervades from the floor to the walls to the whole room, which seems to be without depth, and in which a few objects and half a dozen paintings float. Another method also allowed him, that same year, to create that spatial unity he longed for, and he practiced it with brio in *L'Intérieur aux aubergines:* the shifting of different arabesques which impose the overall pattern and lead it back onto the vertical plane. From then on, Matisse continued to work in this direction, and to grapple with this particularly elusive problem.

The arabesque, as the name indicates, is an oriental sign. Or, rather than a sign, it is a language. "My revelations always come from the Orient," Matisse told the art critic Gaston Diehl. It is true that he worked with the arabesque motif over a period of years, composing paintings by borrowing repeating motifs from fabrics, rugs, wallpaper, and by giving his lines the suppleness of writing. He insisted on the decorative aspect of his paintings and excelled himself more than once in large compositions designed for a specific space, which forced him to restrain his force of expression. However, he was also keen to stress that the art he practiced was not the same as decoration. The expansion of the decorative arts that started in the nineteenth century and continued into the beginning of the twentieth century may have aided him in his search for a balanced, luminous, malleable form, but he did not care to be mistaken for a dressmaker, no matter how famous (like Paul Poiret, for example, whom he knew and admired). Even a vase by Gallé, according to Matisse, should not be judged by the same criteria as his own work. He did not make the traditional distinction

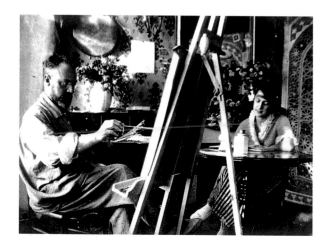

between major arts and minor arts (decorative arts, applied arts, etc.) but this was not because he scorned decoration. On the contrary, it was because he believed that all art should be decorative. Decoration should be considered a specific quality of art, and not a type of art used only to embellish functional objects.

This is what Pierre Schneider summarizes at the end of a brilliant analysis: "All true decorative art requires the presence, in the background, of the sacred, which, in different species, constitutes its only meaning." This is indeed the spirit in which Matisse himself said that "expression and decoration are one and the same" and specified, in his *Notes d'un peintre*: "Expression, for me, does not reside in the passion that shows through on a face or which asserts itself through a violent movement. It is entirely in the way the painting is arranged."

It was in the apartment in place Charles-Félix, the acquisition of which corresponded to an important phase in both his life and work, that the artist was to devote himself over several years to a vast undertaking often criticized even by his defenders. Matisse, who was engaged in an adventure in which he could never achieve satisfaction because its only meaning was as a continual search for an art that was intuitively perceived as distant, never rested on his laurels. Like his

ABOVE
Henri Matisse and
Henriette Darricarrère in
the Place Charles-Félix
apartment, 1921.

RIGHT
Henriette posing for
Matisse in the Place
Charles-Félix studio.

The beautiful Henriette Darricarrère was Matisse's first great muse. She was the queen of the odalisques, the heroine of a great daydream that transformed the painter into the prince of a palace from A Thousand and One Arabian Nights.

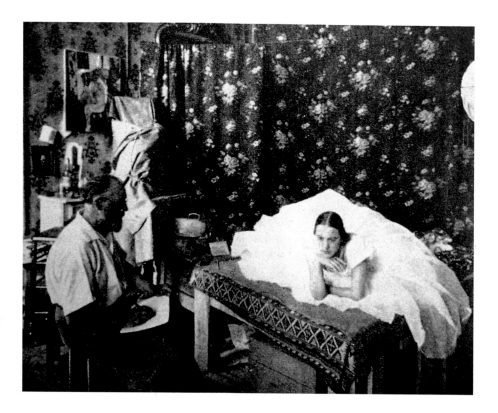

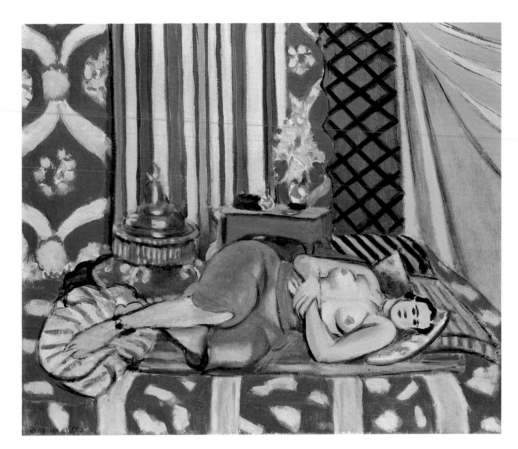

All of Matisse's art consisted in expressing in painting the unity of the world, showing how figure and setting, body and objects, women and fruit are connected. He revealed the same obsession for painting indoors as Cézanne did for the outdoors in Aix-en-Provence.

LEFT
Odalisque à la culotte grise,
1926–27. Paris, Musée de l'Orangerie.

master, Cézanne, he seemed to be walking toward an inaccessible Promised Land, to which he intended to move as close as possible. The grace and complicity of Henriette Darricarrère allowed him, in fact, to lead his painting onto a path he had only explored tentatively until then. There, he found a knew harmony between the necessity of drawing inspiration from a model, and trusting nature, and an imaginative force which made him consider woman not only as a being standing before him, in the simple presence of her personality or the nudity of her body, but as a character from some infinite fantasy.

Henri Matisse did not hide the fact that he was a romantic, a passionate, high-spirited man, and that he tried to express this in his painting, as did Cézanne, whom he often quoted as an example. Images and souvenirs of Morocco came back to him, as did Oriental fantasies, as much due to two trips to Tangiers twenty

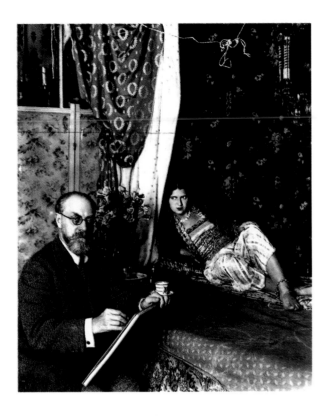

a sumptuous, delicate decorative abstraction. However, this does not seem to have changed Matisse's fundamental focus—at least until the 1920s, when, comfortably installed at place Charles-Félix, he gave free reign to an audacious oriental inspiration in an invasion of odalisques lounging on rugs and cushions, posing lasciviously at siesta time, their languorous flesh showing through thin fabrics, attracting the eye, provocative and seductive.

The odalisque, like the arabesque, is an Oriental figure; it belongs to the same image of luxury as the rich decorative opulence of rugs, the abundance of silky fabrics, the charm of intensely colored ceramics, the hazy light that filters through lattice windows. The odalisque already had an important place in nineteenth century art, with the harem scenes brought back from Morocco by Delacroix, and the whole vogue for sensual nudes that inhabited Oriental-style painting. This exotic component of academic painting, heady with all the perfumes of Arabia, did not recognize that

It was rare, at tea time, that Matisse did not provide a few cakes for his models, knowing they did not always eat well.

ABOVE
Henri Matisse with his model, Zita, in the Place Charles-Félix studio, 1928.

years earlier as to the painting of that other great artist of the nineteenth century, the first liberator of color and brushstroke, the genius of romantic art in France: Eugène Delacroix. Matisse was an artist whose reactions were slow: before he could really transpose an experience into his painting, he needed to give the experience time to mature, to make its way into him and return, find a form of expression in its own good time. Crossing the straits of Gibraltar and discovering Morocco was a fundamental event for Matisse, a meeting with light and spatial qualities, a taste for life, and an aesthetics of life that had a profound effect on him. A few paintings were born of this, including the strange *Marocains* we have already mentioned, which imposed

impressionism was creating a salutary revolution in painting. Academic painting had a carnal vision of the Orient, but its elegant successors were mainly only superficial tourists, bringing back photographic images but remaining foreign to the spirit of the countries they set out to portray or even to celebrate. Later on, once Matisse's painting had been cleansed of its academic defects by impressionism, then fauvism, and he had mastered the techniques he required, he reinvented Orientalism, in opposition to modernism which, since cubism, had been the rule. This is because the theme he was handling was not banal for him, but was the object of an obsession, and also because he approached it in a new, original way, in harmony with the subject.

Matisse confessed to André Verdet in 1948, "The *Odalisques* were the abundant fruit of both a happy nostalgia, a beautiful, living dream, and actual experience that was lived almost in ecstasy in the days and nights of a poetic climate. A pressing need to express this ecstasy, this divine nonchalance in corresponding colored rhythms and figures and solar and savory colors." Henriette Darricarrère had her role to play in this "ecstasy." She inspired and fascinated Matisse. She was the supreme odalisque, the queen of the imaginary harem of this artist who invented his own Orient in his studio in Nice—a town which, like sparkling Marseilles, faced the east, and which, since the mid-nineteenth century, had received numerous members of nobility from the Balkans and the Middle East. For Matisse, Henriette was the odalisque. In fact, she represented the Orient itself. She was also the woman in the studio, the model who had to find her place in this decorative, ornamental space among the fabrics, rugs, and pottery; she was the star of the strange theater the artist invented for himself.

Some people were to reproach the painter of

Jeune Fille à la robe verte,
1921. New York, collection of
Mr. and Mrs. Ralph F. Colin.

wave from the ocean floor?" In fact, he later added, after many years of research, the *Odalisques* were a "synthesis that was both moral and pictorial. . . . A rhythmic desire for abstraction battled within me against the natural, innate desire for shapes and colors that are rich, warm, and generous, where the arabesque tried to impose its supremacy." Why could he not be obsessed with form, be an artist keen to create form and be at the same time a sensual, voluptuous man? In opposition to the major trends in contemporary painting, whether figurative or abstract, Matisse asserted the importance of the subject. His paintings expressed the emotion that feminine presence and feminine beauty aroused in him. He painted women, and art specialists and enlightened amateurs were so flabbergasted and shocked that they saw only that: a subject which, in a painting, cast a shadow on pure form. In fact, Matisse put the flesh back into painting, which, since Delacroix, had been singularly lacking in it. Matisse summoned all the sensuality of the Orient to give new blood to a western art form that was dynamic, inventive, but somewhat detached from real life, notably under the effect of the rolling wave of cubism.

Like all the painters of his generation, Matisse was intrigued by Japanese art, in which the impressionists already had an interest, and to which Vincent Van Gogh had paid more than one significant tribute. He was not afraid of influences, and indeed was always eager to acknowledge all his debts to other art forms, so he carefully studied the Japanese prints that were highly popular at the time. He said that they were "a lesson in purity and harmony in the freshness of a revelation." In the prints there was an expansion of color, a prominence of the decorative, a sense of line and the oblique view point which had for several decades contributed to renewing composition, and which Matisse made his nectar. The main characteristics of Japanese art were gradually being assimilated by Western painting, even becoming banal in an avant-garde that had escaped the

odalisques for his lack of seriousness, for not being demanding enough and for shunning the major problems that modern art was tackling. They probably had not really understood what he was doing, or not looked at it properly. To André Verdet, Matisse complained about this incomprehension, and of a certain alienation of a great number of his most advanced admirers, who accused him of exoticism, Orientalism, facile seduction, cooling of inspiration and pictorial treatment. He wondered: "Have I let myself be carried away by too much enthusiasm in the pleasure of creating paintings, a pleasure which swept me off my feet like a warm

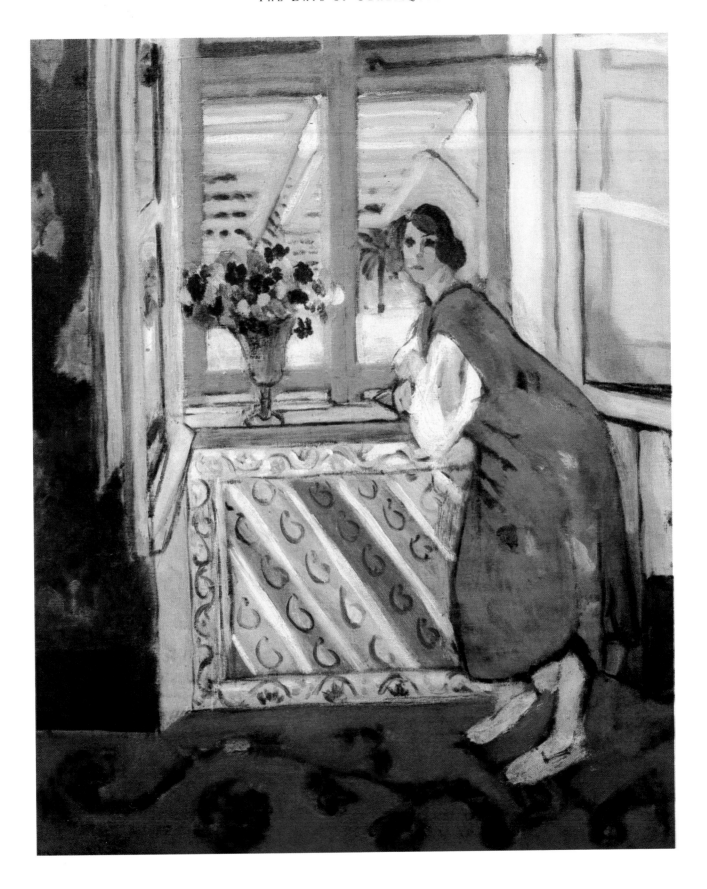

constraints of perspective fixed by the Renaissance. It was true that Japanese art exalted decorative objects, the fabrics and ceramics for which Matisse had always had a pronounced taste, and it would be easy to believe that this was a further reason for his interest. But, strangely enough, his Orient was Islamic, and it was through Andalousia to North Africa that he chose to steep himself in exoticism. He had acquired a taste for Arabic ceramics very early on. Examples were exhibited in the Louvre, and they were given a place of honor in the 1903 exhibition at the Musée des Arts Décoratifs. Moreover, at the Universal Exposition in 1900, he had been far from indifferent to the pavilions of the North African and Middle Eastern countries.

Pierre Schneider noted accurately that "for Matisse, Orientalism makes way for Orientality." Which meant that, contrary to many artists who, like Delacroix, sought out exoticism in North Africa and fell under the charm of foreign customs and extraordinary landscapes, Matisse gave only relative importance to the area. Although he enjoyed painting in Tangiers and wanted to return, his brief trip to Algeria in 1906 was a fiasco. He did not like the desert, that infinite beach with no sea, found the light blinding and the belly dancers disappointing. He liked neither Algiers nor Arabs and was extremely happy to return to Collioure. It was in Collioure that emanations from Algeria came back to him, on the occasion of the astonishing *Nu Bleu,* to which he added the subtitle *Souvenir de Biskra,* and which only evokes North Africa through the presence of a few palm trees, while the painting is dominated by a large, expressionist nude. From this time onwards, both in his studio and in his painting, the ceramics, fabrics, and rugs were always present. He multiplied the decorative effect of them within his paintings, even on occasions allowing them to invade, with the repetition of their motifs, the entire space of the canvas. He brought a chest full of mural ceramics back from Spain. Pierre Schneider defined the features

that may have attracted the painter: (...) pure color, applied in solid flat shapes, drawing reduced to line, handled in arabesques: no more shade or sculpting; the space of the work is rigorously two-dimensional." To which must be added "the magical blues" and the formal intervention of the language, which compensates for the ban on figural representation. Schneider puts his finger on the echo of what preoccupied Matisse in the painting he could find in Islamic art, and particularly in the decorative object that most fascinated him: the rug. "These characters that are to be found in Persian dishes and in the plan of an Egyptian mosque, in a page of the Koran and in a sculpted wooden door in Cordoba, are found in their purest form in the rug. Mobile, brilliant, but fragile, delicious mask thrown over the face of the void, these complex arabesques

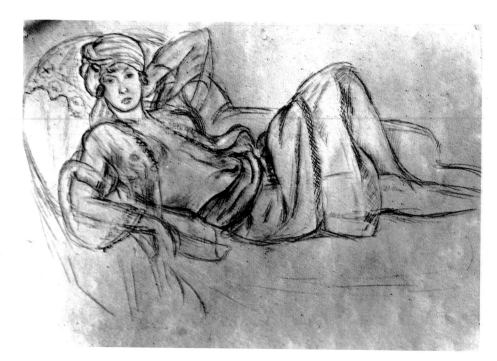

The nude captures Matisse, who sublimates voluptuousness to translate it into painting.

Étude pour Odalisque au pantalon rouge, *1921.*
Private collection.

and abstract panels with non-figurative colors in the throes of the intoxication of deployment according to a plan that is imagined as interminable, the rug, whether Egyptian, Iranian, or Turkish, is both ravishing and liberating, splendid and vertiginous." Artists had undoubtedly always paid attention to rugs: Van Eyck, Memling, Holbein, then Gauguin, Moreau, Denis, but Matisse gave them the status of stars as no-one else had done before, and he did not merely represent them— he captured their spirit.

Rugs and fabrics played a major role in more than one of Matisse's paintings, as the decor itself became the subject of the painting, the very space of the painting where the other objects had to find their place and their pose, including the model, Henriette Darricarrère. Or, in other paintings, it is the fabric the model is wearing, a *gandourah* or exotic blouse disguising her as a woman from a distant land that inspires dreams. That, too, had always been done in painting, even (if not above all) in the most academic of painting, and in the wake of the Orientalism which was cultivated just as much in the Parisian studios as in the shadows of

the harems or the sands around the oasis. Matisse brought a natural freshness and vigor to it, as well as a determination which established between the fabric and the canvas a new complicity which even gave certain paintings the aspect of a strange patchwork.

For a painter as much under the influence of Cézanne as Matisse was, to paint a woman in an interior was to re-pose the main question to which the great painter from Aix devoted himself when he insisted on painting figures, nudes, in landscapes. The idea itself was not new, of course, as it also belonged even to the academic tradition, which had never shied from showing women's bodies at liberty in nature, with the pretext of mythological evocations or reference to some earthly paradise, a kingdom of innocence with no conception of original sin and therefore no censorship. Such scenes were always considered as the presence of characters in a decor, with everything in perspective and no confusion. Even Manet's *Le Déjeuner sur l'herbe,* which created a scandal because of its lasciviousness, did not break with this convention. Impressionism, which was too naturalistic to have nude girls running

*"The object in itself is not
particularly interesting. It is
rather the surroundings that
create the object. This is how I
have worked my whole life long,
in front of the same objects
that gave me the strength of
reality by directing my mind
towards everything those objects
had endured for me, and with
me. A glass of water with a
flower is different from a glass
of water with a lemon,"
Matisse explained.*

RIGHT
Anémones dans un vase
de terre, *1924. Bern, Kunstmuseum.*

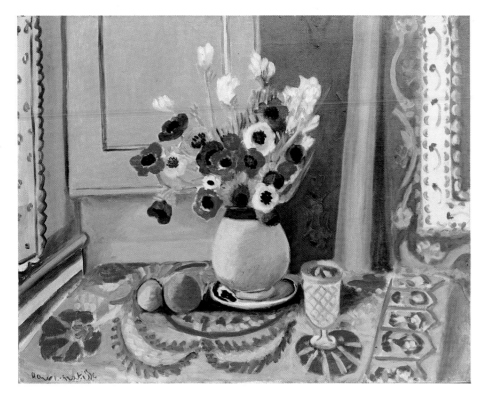

around in the fields, had nonetheless changed the rule slightly by allowing the clothed figure to melt into the landscape, by unifying the figure and the landscape in the same light which dissolved the contours. Cézanne did not confine himself to such superficial realism, and the problem he battled with was completely different: the character, nude, the bather, had to be a part of the structure of the landscape; they had to come together in a single composition, a painting composed like an organism where each element vibrated in unison with the others. Matisse took up the same problem in a different way. He always acknowledged his debt to Cézanne, and his admiration for the painter, and for many years he kept with him a small canvas of the Baigneuses which he bought in his youth, and which, at the time, represented a considerable financial sacrifice for him (Gertrude Stein said Matisse had to sell his wife's engagement ring to buy it).

It was Cézanne's teaching, coupled with that of Pierre Puvis de Chavannes, that brought about two

major paintings, at the beginning of the century: *Luxe, calme et volupté* and *Le bonheur de vivre*, as well as *La Danse* in Moscow. And it was unmistakably as a disciple of Cézanne that Matisse tried to resolve the problem of the human body in space: how could the painting evolve from the reproduction of a vision into formal creation? Stated another way: using an image, how can a painting be made that is more than an image, but a formal equivalent, which no longer considers the model or the object as external to itself but integrates it into its structure? In conventional painting, there is a difference between what is inside and outside a canvas. The painting refers to a reality that precedes it, which it attempts to reproduce. In Cézanne's painting, as in the painting of Matisse, the canvas takes the place of reality, is the reality, a reality other than the one in which ordinary life takes place. When he undertook his major decorative compositions, Matisse had less need to work with the model. This is because the relationship between the artist and the model induces a painting

65

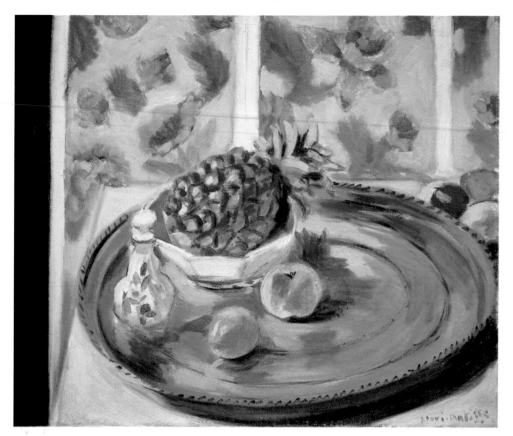

"One must know how to retain that freshness of childhood and preserve that naiveté. One must be a child all one's life, while at the same time being a man, find one's strength in the existence of objects-and not have one's imagination blocked by the existence of objects," confided Matisse to André Verdet in 1952.

LEFT
Nature morte à l'ananas, *or* Le Plateau marocain, *1924. New York, private collection.*

that is too personal, too emotive, and exceeds the function of decoration. However, this imaginative work was only possible for him because he was at the last stage of the process of abstraction which he employed when painting a model: in his major decorative works he is able to paint silhouettes which are signs of women because he painted women—and always painted them in a stylized, ethereal way, sublimating them into shapes and colors that are an integral part of the painting.

The series of *Odalisques*, which was a tribute to the model, to the female form, and praise of Henriette Darricarrère, was a superb manifesto of the ambivalence of the painting that is and is not the model, which takes the carnal presence of the model and shows an illusory double of it. For in the end, at the center, at the heart of the painting, in the most obvious fashion, the truth is always the same: the presence of a woman whose fascinating seduction lies in her nudity, the taboo that the painter is allowed to see in his studio (professional privilege) and to show in his painting. That is also what constitutes the magic of the odalisques: their clothing only serves to stress their nudity, which is all the more titillating because it reveals itself before it exposes itself, holding back desire behind the fragile barrier of clothes. Pierre Schneider says this nicely: "The room is often reminiscent of a corner of a harem, because the woman lies there sleepily, converses, her eyes vague, her fingers absentmindedly playing with a string instrument, naked or dressed in sumptuous apparel sometimes deliberately ethnic, and her sole occupation is to prepare herself, through luxury and calm, for the voluptuousness of man, who is present here only in the negative: by his availability and her expectations of him."

And so, a studio painter who hardly ever took his brushes and easel outside, and who only drew the odd flower in the gardens where he occasionally took a stroll, Matisse invented in Nice, a short distance from the market where the Riviera population loudly expressed its presence, the luxury of an Oriental palace, and satisfied the dreams of a Sultan.

Nice is a gourmet town, and knows how to show it at carnival time, when some of the floats are decorated with Rabelaisian themes. In 1936, for example, a float celebrating the glory of the *socca* (a local specialty with a long tradition) was described in the program of the festivities in the following way: "The float is dominated by the traditional *socca* seller who, no doubt to be more at ease, is wearing an enormous pan on her head in which the golden cake is browning. Various customers: a gentleman with a top hat, a dancer who has escaped from the famous square dance of the Goulue; are struggling to be served a triangle of the tasty cake. At the front of the float, a street seller, carrying a lovely cancan dancer on his shoulder, is pushing a cart loaded with the tasty product. Lower down, two *socca* sellers are hailing the customers energetically with "Socca, come and buy some socca!"

Was it a man other than our indoor painter who descended the three flights of stairs to eat a salad Niçoise at Camus, as Michel Georges-Michel said, and dined here or there on some seafood, perhaps *chez* Tessier, always proud of his Marenne or Portuguese oysters, or at Jacque's, at the Dôme? Without a doubt it was the same man, with his dreams, the work in progress, a painting not yet completed, a model whose inspiration he had not yet used up, a series of drawings still to be done, and more. As he had never cultivated his identity as an artist, the people who did not know who he was could quite easily have mistaken him for a doctor, or some other professional person, another respectable citizen of Nice, on his way to buy candied fruit at the port, at Florian's or opposite the Opera House at Henri Auer, who boasted of a "world reputation," or even at Gainon's, another famous confectioner (and he usually had some cakes for tea breaks, as he knew his models did not always eat a substantial lunch). Perhaps he had even tried the delicious pasta at M. Lerouge and the olive oil from Nicelle's.

With Family

Henri Matisse had already been living in Nice for over ten years. He went to Paris only briefly in the summer to flee the heat and the influx of tourists. He was set in his ways like a bachelor and a hard-working artist, who rarely goes out, has few friends in the area, and whose mind never wanders. Occasionally he went to the cinema or to a concert, sometimes as far as Monte Carlo. Auguste Renoir died in 1919, but Matisse could have visited Pierre Bonnard in Antibes, André Rouveyre in Vence, or the painter Simon Bussy at Roquebrune, for example.

He was sometimes seen at the Riviera Glacier and at the Grill Room at the casino on place Masséna, at the Régence, the Brasserie Royale, and the Brasserie de la Marne on avenue de la Victoire, at Monnot's, and at the Hôtel Volnay in Albert-1er square. He took a stroll after lunch, sketched at a café terrace, daydreamed, wrote a few letters. He was at home in the old quarter, in the midst of the bustle from which, by nature, he kept his distance. At the end of 1926, an apartment above the one he was living in became free; he moved into it to take advantage of more space, a better view, and a big balcony on the corner of the building. There were nine rooms, plus the kitchen. His main studio was a large room with *faux* marble walls,

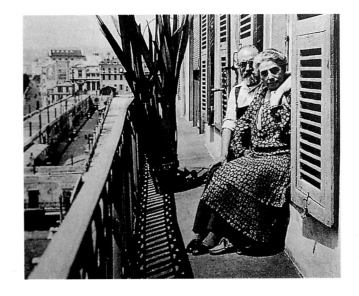

Henri Matisse and Amélie on the fifth-story balcony of the building on Place Charles-Félix, 1929.

in the corner of the building. Another room, smaller but with more light, with large French windows, had white walls with false tiles drawn on them. His room was beside this, next to the dining room, close to which was Amélie's room. Mr. and Mrs. Matisse were spending more time together than in previous years: Amélie moved back to Nice. Two other small rooms were

available for the children and grandchildren to stay in. In 1923, Marguerite had married a specialist in Byzantine art, Georges Duthuit, who became a fervent admirer of her father's painting, finding it to be closer to the spirit of Byzantium than the painting of Rome, and admiring the fact that it had broken with the tradition of the Renaissance. In 1925, Matisse's children and in-laws went to Italy together, and traveled as far as Sicily, tracing the footsteps of what remained, scattered here and there, of Byzantine art, which Matisse himself had highly appreciated when he went to Moscow, when he was working on *La Danse* and *La Musique*. There, he had discovered that prodigiously decorative art, the icons that set a figure on a plane with no depth, and the opulent architecture that abhors empty spaces.

In a text published in the review *Macula*, Dominique Fourcade described Amélie in the following way: "Mme Matisse is a delightful Toulousaine, with noble bearing and magnificent, black hair in a charming style, especially at the nape of her neck. She has an attractive bosom and beautiful shoulders, and gives the impression of being a person of great goodness, strength, and gentleness, despite the fact that she is actually quite timid and reserved." This was few years earlier, when they were younger and she was still her husband's model. Amélie had now aged somewhat and her hair had become grayer. She had become a calm, patient, and affectionate grandmother. She had known for a long time that her husband put his painting first, before their relationship, although he was always faithful and affectionate toward her. In one photograph they are shown side by side, seated at the dining room table, at coffee time. The background walls are covered with the painter's works. Although they are sitting

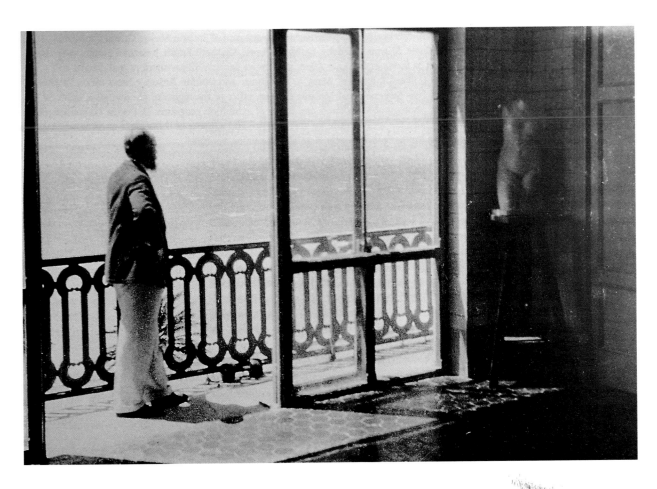

close to each other, there is a slight distance between them. A piece of bread and a few oranges remain on the table beside the coffee cups. A small dog in its basket also appears in the photograph. This is a portrait study of an ordinary, elderly couple among odalisques.

At the turn of the century, Amélie Matisse was her husband's first important model. He painted her with a guitar, in a hat, in a madras headdress, in a lavender dress, a Japanese costume, with a parasol, by the water's edge, and in front of a window in Collioure. She also posed for *Le Goûter*, a canvas that finally led to *Luxe, calme et volupté*. She only partially shared Matisse's life, but was his indispensable companion during these early years when he asserted his personality and began to show his talent and come to grips with what was already apparent as his genius. The *Portrait de madame Matisse* (1912–13), at the Hermitage, is a masterpiece

Henri Matisse on the fifth-story balcony of the building on Place Charles-Félix, 1929.

predominated by varying shades of blue contrasted by just two bands of ochre linked by a skillful play of straight lines and curves. Amélie wore her hair up in a bun and wore a small hat, and her eyes were reduced to two black holes, the way Cézanne often depicted eyes. It was a painting of immense softness, with a dreamlike quality that stood in stark contrast to another portrait painted in 1905, known as *La Raie verte*, in which the woman has a green band across the fore-head, which descends down the bridge of her nose. It is a brightly colored composition, with sharp tonal quality in which the face is streaked with vivid, thick brush strokes, quite unlike natural skin texture. Amélie, who was thus made into a subject of painting, a pretext for

"At the outset, in 1918,"
explained Matisse, "I lived
in the Hôtel Beau-Rivage.
When I returned the following
winter, I went to the Hôtel de
la Méditerranée, where I spent
each winter, from October to
May, over a period of five years.
I next took an apartment at
1, place Charles-Félix, on the
top floor, that overlooked the
marketplace and the sea."

BELOW
Henri Matisse and Claude
Duthuit on the balcony.

a canvas, was no less beautiful, with her even features crowned by thick, black hair coiled tightly on the crown of her head, emphasizing her deep, expressive eyes. The astonishing gulf between these two paintings and the female figures reveals Matisse's rapid progression in the space of just a few years—from the harshly colored expressionism of fauvism to a more subtle search for harmony and more intricate composition. Yet, between the two, there is no obvious change in attitude, or in the painter's feeling for his model, unless, as Matisse repeatedly invites us to do, one examines the painting more closely, beyond the depth of the superficial image. From the first portrait to the second, it would seem that his painting has evolved from passionate sentiment to respectful tenderness. This represents the normal development of a relationship, and as such would be unexpected from a man for whom art came first and foremost, and whose very family yielded to the demands of his craft to such an extent that the children did not talk at table for fear of breaking the master's concentration!

In the small studio, Matisse liked to recline on a comfortable armchair with his feet resting on two large footstools, almost managing to lie down altogether. On a sculptor's bench, two small figures seemed to be scrutinized by an African statue that looked down over them from the cupboard on which it stood. A large table covered with papers, a huge green plant, and a small Moroccan table completed the decor.

After the move, Hélène Darricarrère continued to pose for Matisse, but she inspired him less as he became more familiar with her. She gradually drifted away from Place Charles-Félix, but was replaced by other young women who had no doubt also escaped from the Studios de la Victorine. They would come

to be mused over, drawn and painted: Lisette, Lily, Loulou, Zita . . .

Matisse preferred the morning light for painting. He thought it finer, softer, and more kind to color. He used the afternoons for drawing. He worked continuously, but needed exercise, so he enrolled in a sailing club to take up rowing. He bought a boat, and would go rowing almost every day in the Baie des Anges. It was perhaps during these moments of solitude between sea and sky that he began to dream of another space, another light. Now that he had exhausted his impressions of Morocco and drawn what he could from the teaching of the Orient, he dreamed of going further west, to the Pacific — to the Galapagos perhaps, those fabled islands he had once heard praised by a German baroness, where not so long ago, explorers were supposedly eaten alive. Pierre, his eldest son, had settled in New York, which gave Matisse an excellent opportunity for a first stage on his journey; he would arrange everything else from there. On his return, in an interview with Tériade for *L'Intransigeant,* he explained exactly what he had in mind when he set off: "Working for the past forty years in European light and space, I've always dreamed that there might be locations with different proportions, perhaps in the other hemisphere. I have always been aware of another place in which the objects of my imagination dwelt. What I was looking for was something other than real space." Matisse left in search of his own space, a plane within himself, in his imagination and subconscious — a space that he more or less captured in his studio, in what he was later to call "the richness and the silvery clarity of the light of Nice," a plane for which he sought a counterpart in nature.

On March 4, 1930, the streamer *Ile-de-France* came within sight of the Statue of the Liberty and Matisse fell head over heels in love with New York. In a letter to his wife, he praised "the great American illumination," and the order and immensity of the space. He

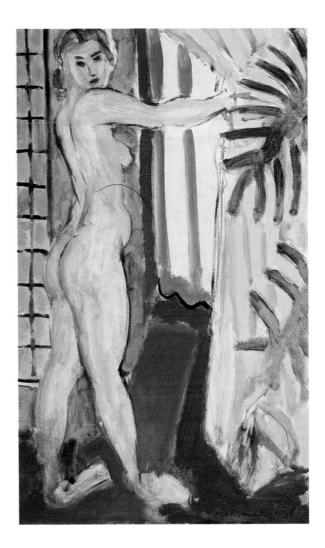

Nu debout devant la porte,
1936. New York, private collection.

quickly visited Broadway and Harlem, but was not enamored of either. Thence to the zoo and the Metropolitan Museum of Art, and he felt "twenty years younger." He was somewhat tempted to remain longer, but took the train, *The Chief,* to travel across this America whose light, he remarked, was utterly amazing. Colors were brighter, and nature was ""entirely new." In Los Angeles, he imagined he had discovered a Riviera on another scale. He then embarked on a merchant marine ship, the *Tahiti.* The new plane was there, ". . . the deep-blue sea: surrounded by an ibis-gold and opaline-blue

amazed by the fruit, flowers, and fish. He was ecstatic in his praise of the "magnificent race" that inhabited the island. It was evocative of Da Vinci, Raphael, and Maillol. He dreamt of bringing back one of the pretty girls to Nice, where he could paint her at his leisure. And he sent postcards of a few of these delightful ladies to his friend Pierre Bonnard. He painted little, sketched a little more, and bathed in the lagoon. He took a few photographs of the coconut trees using a small camera that he had taken with him for the occasion. "The light of the Pacific, of the islands, is like a deep gold goblet into which one gazes." The musician in him listened closely to the sound of the waves and the leaves of the coconut trees

But the glaringly beautiful climate and uninteresting company soon became boring as the oppressive heat and humidity sapped his energy ("It is as if the light has become fixed for eternity"). It was impossible for him to work this far away from his studio. His mind was preoccupied with an unfinished canvas which awaited him there on the easel. However, this melancholia vanished when he visited the leeward islands of Morea and Touamotou, and on the way back to Marseilles, when the ship, the *Ville de Verdun*, stopped off in Martinique and Guadeloupe.

When he later related the trip to Bonnard he insisted that the greatest revelation for him had been swimming under water with his eyes open. He described the entire journey as a great revelation: ". . . pure light, pure air, pure color: diamond, sapphire, emerald, turquoise, and fabulous fish."

Henri Matisse had toured around the world and had returned to Nice to begin a new phase in his work. Fueled with bold impressions and new images, he filled his place Charles-Félix apartment with imposing plants such as philodendrons and magnolias, shells, and birds. But he didn't seem to realize to what extent he had been captured by Oceania.

In August, back in Nice, he returned to *La Robe*

crown" (letter quoted by Pierre Schneider); the flying fish, sea swallows, and the clouds that gave the sky "a weightless luminescence." He hoped this experience would provide unforgettable memories.

On the way to the Galapagos, Matisse changed his mind. He disembarked at the first port of call, Tahiti. One could have believed that Gauguin, the great master of island exoticism, who was no small force in the explosion of fauvism, had drawn Matisse there. But Matisse was to explain on more than one occasion that this painter had not been foremost in his mind, and while he had admired and had been greatly influenced by the master in his youth, he had no wish to follow in his particular footsteps, given that he had not even made the decidedly easier pilgrimage to Aix and Mt. Sainte-Victoire to pay tribute to the spirit of Paul Cézanne.

On March 29, he disembarked at Papeete. He was

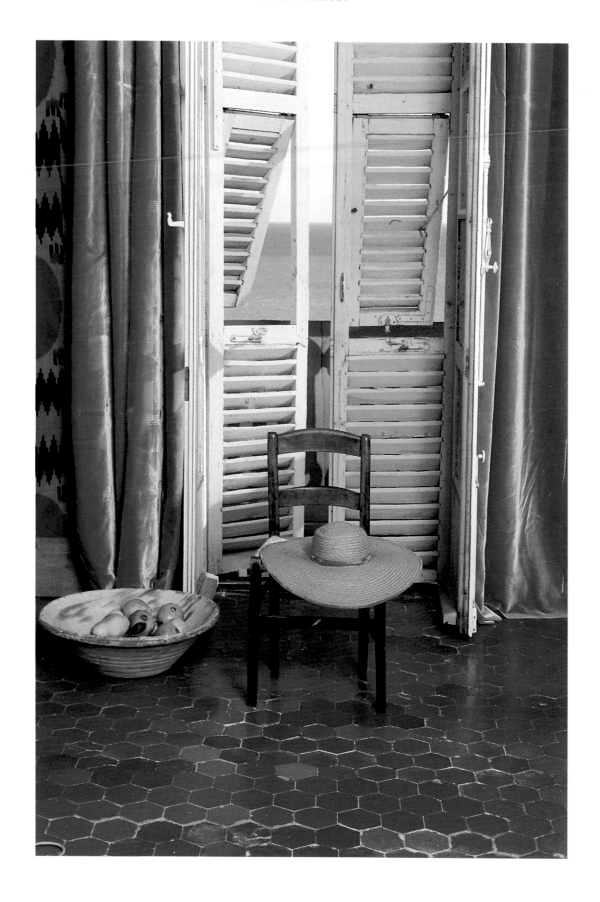

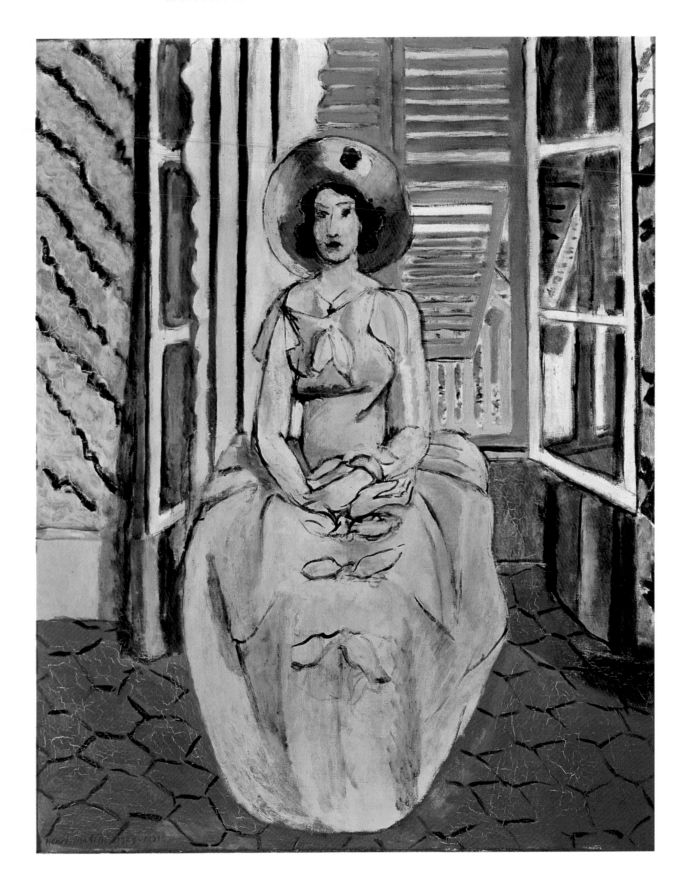

jaune, the canvas he had left partly finished when he embarked upon his trip. He sculpted the *Tiaré,* but seemed in no hurry to exploit his exotic impressions. He was aware that they would take time to develop within him, before he could put them to work.

In September he returned to the United States, where he was invited to sit on the Carnegie prize jury. He had been a recipient of the award himself a few years previously. He went to Merion, to the home of Albert C. Barnes, a multimillionaire who commissioned from him a large decorative work for what was already a small but exceptional museum of modern art. This was to be *La Danse.* The work posed similar technical difficulties to that which he had encountered in *La Danse* for Chtchoukine's salon in Moscow. The triptych measured approximately three by four yards but the sheer scale of the piece was further complicated by the fact that the upper edge of the three panels formed an arc.

He rented an empty building on rue Désiré-Niel. It had been either a garage or perhaps an abandoned cinema, part of the Victorine, and there he developed the gouache cut-out technique which enabled him to make multiple trial layouts of his composition. Later, when he was confined to bed from morning until night, he transformed this technique into a full-fledged artistic discipline. He worked for over two years on the project, and made three versions of *La Danse.* When he thought the masterpiece was nearing completion, he discovered that he had been using incorrect measurements. The new dimensions completely altered the balance, and to simply correct what he had just completed was out of the question. He had to start all over again from scratch. The three discarded panels were later acquired by the Musée d'Art Moderne in Paris, where they were to languish for a long time in storage before being exhibited as they deserved.

In May 1933, he crossed the Atlantic once more to watch *La Danse* being installed in Merion, in the private museum that is now the Barnes Foundation.

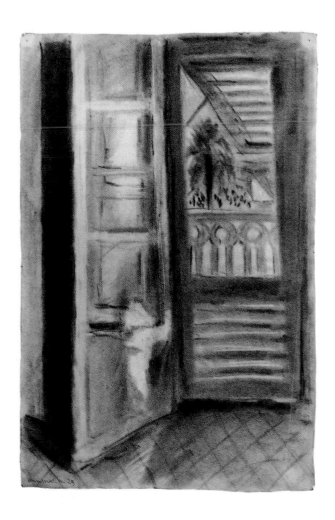

ABOVE

Fenêtre ouverte, Nice, *1929.*

Private collection.

OPPOSITE

La Robe tilleul, *1931.*

Baltimore Museum of Art.

The years 1930–33 were, "a time of perfecting, resuming, and reflection" for Matisse, writes Isabelle Monod-Fontaine, in the preface of the first book by Lydia Delectorskaya.

La Danse was a new challenge, a great innovation in which Matisse synthesized all that he had learned about painting and his conceptions of art and life, forged over the years. The work he produced was a kind of manifesto for lyrical radiance, evidenced for the first time in *La Danse* in Moscow, and which he now regularly put into practice. He was, he said, searching for "an architectural painting."

Frequently in Matisse's work, the goldfish plays the role of a kind of symbolic accomplice, a reflection of the painter in that receptacle of light which is both the studio and the bowl.

LEFT
Deux Odalisques, poissons rouges, échiquier, *1926.*
Private collection.

Lydia Delectorskaya was a young Russian woman, born in Siberia, in 1910. After her studies, she emigrated to France and went to Nice in 1932, where she found a temporary position (for six months, mornings only) as an assistant to Matisse. He was a polite, considerate man, who quickly came to understand that she sometimes went hungry. He would often extend the morning session as a pretext to pay her a little extra money "to enjoy a good steak in the small restaurant on the square." He did two or three drawings of her at that time.

In October 1933, Matisse contacted Lydia Delectorskaya when Mme Matisse was in need of a nurse. She became a sort of lady's companion and, after a while, moved into Place Charles-Félix, where she was given board and lodging, and where she remained for twenty-two years. Matisse, at first, paid very little attention to her. According to Raymond Escholier, she was later to become "the great inspiration of the master, with her beauty, her lively expressive features, her wit and spirit."

Nice was still part of Italy when the Russian nobility turned it into one of their holiday resorts. A pact was signed with Italy which enabled the Czar's navy to set up a naval base in the Villefranche roadstead. Alexandra Féodorovna, widow of Emperor Nicolas I, came there for health reasons between 1856 and 1860, and created a fashion for winters in Nice among the Russian aristocracy. It was there, in 1865, that the Grand Duke Nicolas Alexandrovitch, heir to the throne and betrothed to Maria Féodorovna, died. Maria eventually married Alexander III, and, after his death, returned to Nice in 1896 out of concern for the health of her son, who suffered from tuberculosis. In memory of her departed prince, Maria Féodorovna decided to build a church for the ever-increasing Russian community. The project took a broader scale than the church on the Rue de Longchamp in Paris, and took a long time to complete. It was only on December 18, 1912, just five years before Matisse's arrival in Nice, that the traditional Russian cathedral was officially opened, in Bermond Park, a property which was at that time owned by the Czar and was the place where Nicolas Alexandrovitch had died. Five golden domes rose over an opulent building which seemed to have been imported intact directly from Russia. It had porches

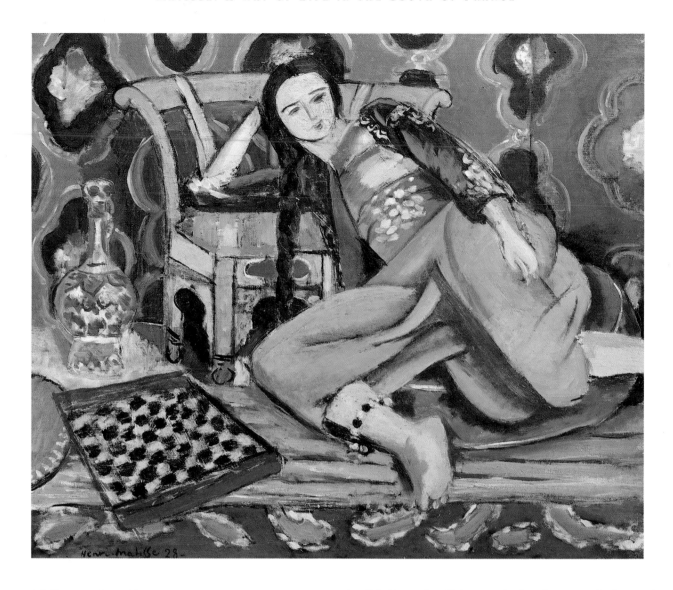

Odalisque au fauteuil, 1928.
Paris, Musée d'Art Moderne de la Ville de
Paris.

framed in sculpted marble, great mosaics, and a three-tiered iconostasis with countless icons. This decorative array of orthodox art must have pleased Matisse, who had already made the trip to Moscow, and it is likely that he visited it at least once.

While he was totally immersed in *La Danse*, Matisse temporarily gave up life-painting on canvas, but after the masterpiece was delivered, he took it up again. As Isabelle Monod-Fontaine pointed out, it was Lydia who reawakened the painter-model-canvas love affair in all its intensity. This eternal triangle was at the heart of Matisse's life and work. The blossoming of this relationship, which began in early May 1935, and continued until November, was without a doubt the inspiration for the *Grand Nu couché*. This was a major canvas belonging to one of Matisse's periods, much like *Nu bleu* of 1906. This painting integrated the painter's entire development since that distant period when the expressionist ardor of fauvism had reigned. Matisse was a painter who, between his easel and vast decorative works, intimate portraits and submission to commissions, found a balance and opened the way to what was to become his *oeuvre* over the following years.

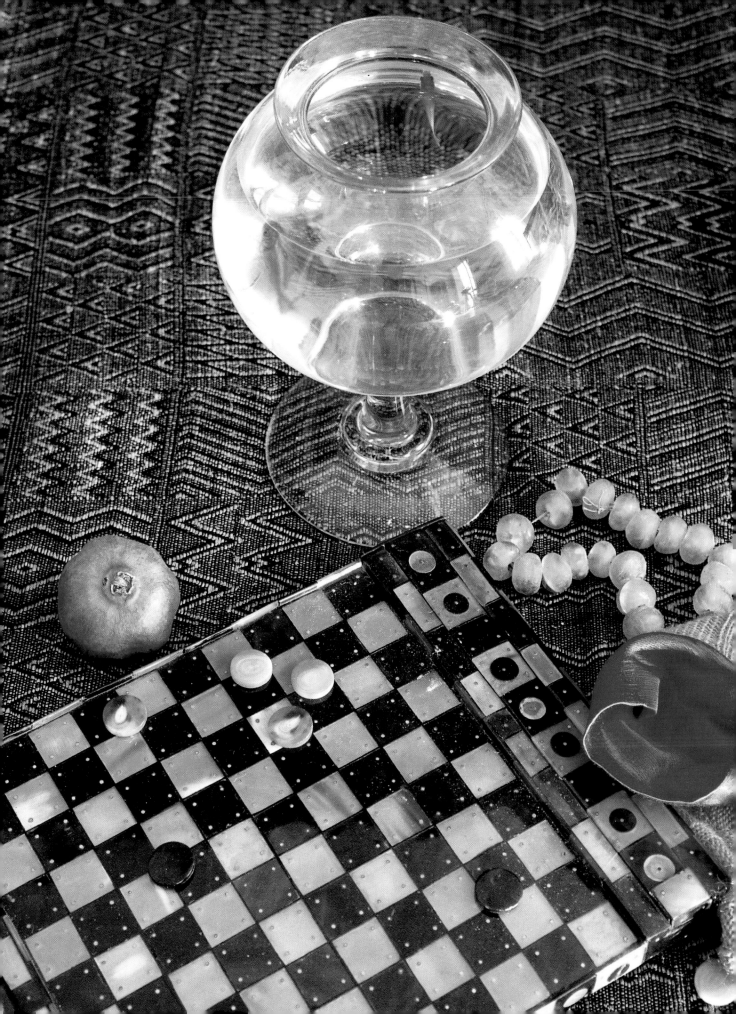

Odalisque à la robe jaune,
1937. Philadelphia Museum of Art.

"He worked all day," Lydia was to say, "in his studios at the end of the apartment, but with each break he would pass a few moments at the bedside of Mme Matisse, who was forced to rest for a large part of the day. I would remain there while they chatted about this and that, with Matisse's mind visibly still riveted to his work."

Lydia was a very pretty, very blond woman, although Matisse seemed to be interested only in dark-haired beauties from the south of France. One day during a break, the painter asked her, or rather, ordered her not to move. He approached her, she recounted, with a sketchbook in hand; did he intend to draw her? He sketched her in a pose that was natural for her, her head down on her arms, folded over the back of the chair, a position that she would assume for him often. He started over again several times, then asked her to really pose for him.

This was how she became his model for several years, as well as his assistant. When he suffered a shoulder injury, she scraped back a canvas in progress, as he normally did in order to re-paint it. She then became his secretary. Matisse addressed her as Madame Lydia, as she was to become known by his entourage. She had, in fact, already worked as a model before she met Matisse. This was one of the few things she could do during a time when foreigners stood little or no chance of finding regular employment. She had posed for three successive studios, but lacked self-confidence, so she had to pretend to be capable, and felt the whole thing was a chore.

Matisse not only sketched Lydia, but he painted and photographed her as well. In photographs she can be seen perched on a high stool in front of the half-completed *La Verdure*, helping Matisse to remove the paint, or dressed in overalls on a stool in front of *Tahiti I*, employed at the same task, or again in front of the *Grand Nu couché*, or posing for *La Blouse bleu*. In these photographs, when she is not seen from behind, although her beauty is obvious, it is her huge, wistful eyes which captivated the observer. Her presence finally annoyed Mme Matisse to such a degree that she left her husband in 1937, and Lydia Delectorskaya was the main witness to the last years of the artist's life, his work, his thoughts, and his doubts.

While she posed, Lydia would observe Matisse and listen to him. Although he stood close by the model, he seemed to forget she was there. At times he would swear, grumble, talk to himself while he was painting, making disparaging comments about his work in a monologue that seemed to belie any satisfaction he derived from it. At first Lydia jotted down hurried

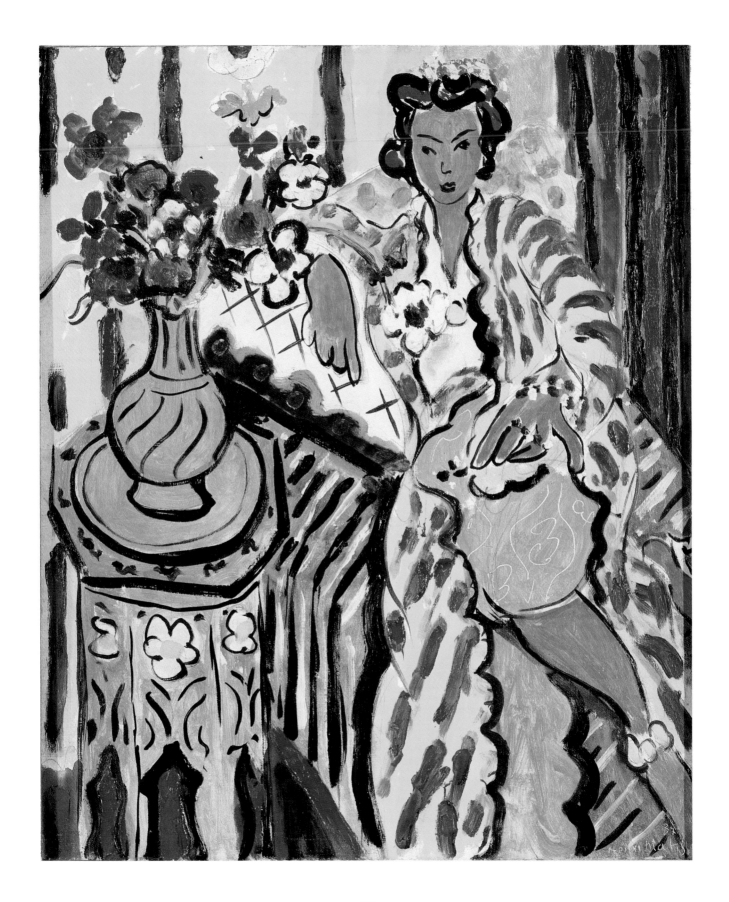

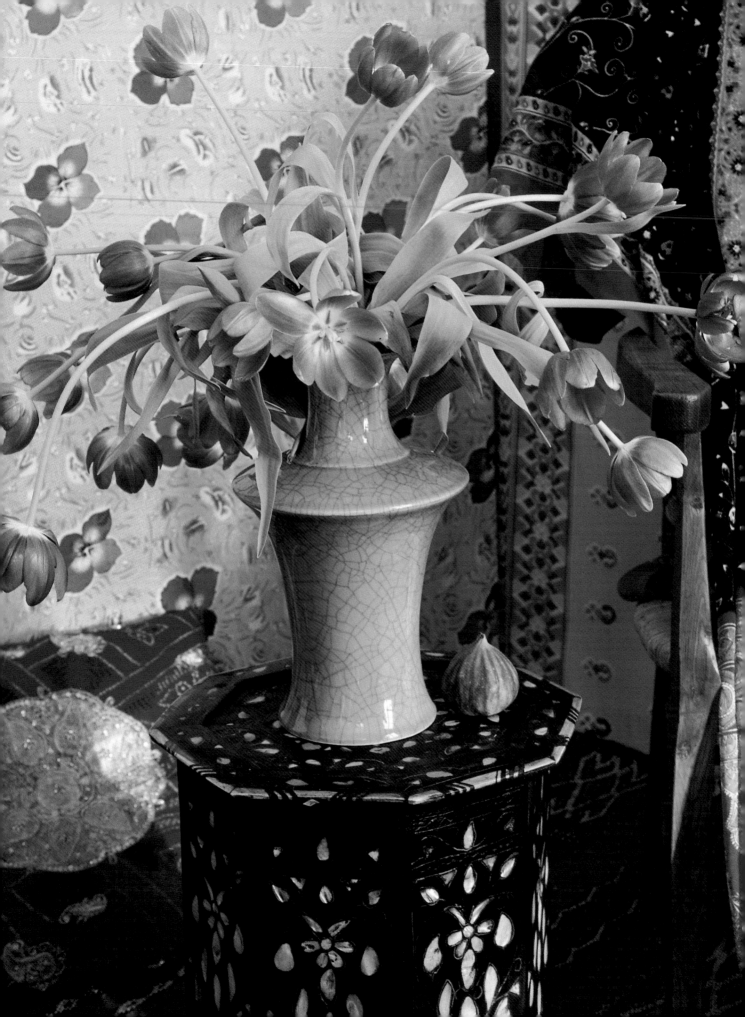

notes after each session. She confessed to Matisse one day and showed them to him, but he only laughed that she was just like the art critics, she didn't understand anything. If she wished to keep notes then he would dictate them to her. Most often, a few sessions were all that were required to complete a canvas, but, curiously, there was always one canvas that occupied Matisse's attention for the whole season. He would return to it time and time again, even starting over again what would have seemed finally to be finished. This was because a canvas could be technically successful but lack the essential element, the emotion which first inspired it. For this reason, Matisse was the only person who could possibly know when a canvas was truly finished. No critic could tell this. He did not hold a very high opinion of art critics in general, and regarded them as failed painters who, at best, could spot a mistake, but had no idea whatsoever as to how to correct it.

The painter and his model . . . Here was a theme that had run through the history of painting ever since portraits were first painted. Matisse would place his model in a setting that he had carefully prepared. The hangings were skillfully placed, and the model was invited to adopt a position that was as natural as possible, in the absence of the usual spirit of constraint imposed in the studios of the Beaux-Arts. Matisse's interest was not in a sophisticated pose, but in the natural presence of the model such as she was to be seen, such as she was willing to reveal herself to the artist, in this particular intimacy. The task of the artist was to bring out not the superficial form, but his own inner feelings and also those of the model—a true visual projection of this spiritual union of two people. The figure, he said, was the most important professional concern of his life. Why did he paint it so close up? Would it not have been better to visualize the model with greater perspective from a distance, which was the accepted practice in the other studios he had visited in Paris, and which was the enforced discipline when he attended the École des Arts décoratifs in Nice? His reply was: "A cake seen through a shop window does not make your mouth water as much as when you enter the shop and smell it." The quick-witted onlooker then made an enlightening remark,

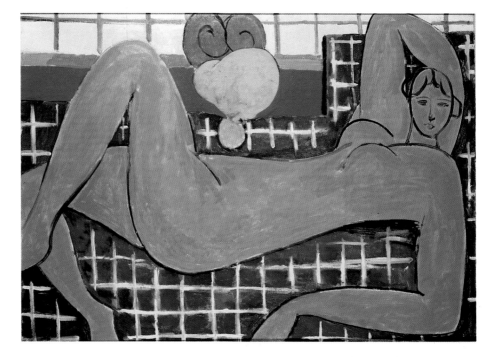

"A canvas must lead to a deep satisfaction, rest, and the purest pleasure of the fulfilled mind," explained Henri Matisse.

RIGHT
Grand Nu se reposant *or* Le Nu rose, *1955.*
Baltimore Museum of Art.

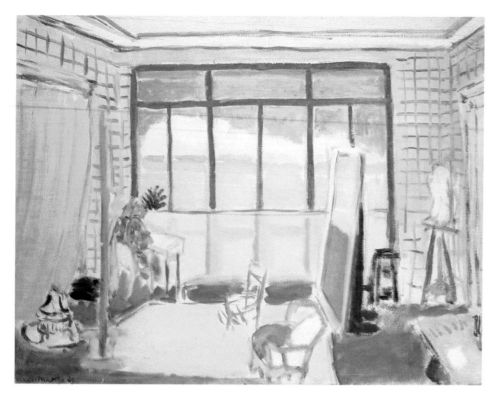

"If I am able to unite in my painting what is outside (for example, the sea)" said Matisse, "and inside, it is because the atmosphere of the landscape and that of my room are but one. I do not have to bring together the interior and the exterior; both are united in my feeling. I can associate the armchair, which is close to me in the studio, with the cloud in the sky, with the rustling of the palm tree by the water's edge, without the need to differentiate between the places, and without disassociating the different elements of my motif, which are but one and the same thing in my mind."

LEFT

L'Atelier, *1929. Private collection.*

perhaps somewhat allegorically, as to the relationship between the painter and model: "And, for example, when he painted a still life with oysters, he had to replace them with fresh ones every other day, before they would lose their appealing appearance. And he would never eat them himself, no doubt to keep alive the attraction they aroused in him." Many drawings of Lydia remain today, including the beautiful "nus renversés" series. Matisse included himself in some of them, but not without an element of humor: he appeared either somewhat stunned, overwhelmed by the spectacle, or simply moved by the painting itself, or perhaps a combination of both.

Matisse with his models was like child playing with dolls. He dressed them as much as he undressed them, inventing costumes for them, looking for what suited each the best, inviting them to correspond to his dreams. For these young women who brought his studio to life with their charms, he had a complete wardrobe—clothes brought back from North Africa, clothes bought at antique and junk dealers, or at the sales of Paris dressmakers. He had fabrics draped around the models in a semblance of garments. Lydia's notes contained references to a whole treasure-trove that she had discovered carefully stored in a closet in the studio: "Embroidered blouses made out of fine, transparent silk, small boleros out of taffeta or velvet." She added that it was "the beautiful, slender Lisette" who, around 1930, was the first model who played along with this, before Hélène Galitzine or Micheline Payot. From one painting to another, an entire inventory of fashion could be drawn up: yellow, blue, green, black, violet, and lemon-yellow dresses, dresses with puffy sleeves, a Harlequin dress, a gray dress with purple stripes, a Persian dress, Rumanian blouses, a purple bolero, an embroidered black blouse, a green blouse, a Slavic blouse, blouses embroidered with flowers, of a type found in abundance in the shops of Nice. Organdy and tulle reigned, and the title of more than one canvas simply designated the garment, or even the hat worn by the model.

On the Heights of Cimiez

Toward the end of 1938, Matisse left Place Charles-Félix and the old market for the heights of Cimiez. His lungs were fragile and his physician advised him to retreat from the seaside and from the humidity, which tends to stagnate on the coast. He ventured only three kilometers from the old lower city where he had spent some ten years in two successive apartments. Cimiez was a place of historical interest near Nice. It had been an ancient Greek colony, and then the capital of the province under the Romans, who built an amphitheater and a spa. A Franciscan convent was established there in the sixteenth century and a large church was erected the following century. Its romantic, Gothic façade was drawn by Count Caïs de Pierlas (who was the owner of a certain building located at 1, place Charles-Félix). Cimiez had been a chic suburb of Nice, a hilltop overlooking the town, where sumptuous palaces had been built, but the Russian Revolution, the economic crisis, and then the war robbed it of some of its vitality and elegance.

Matisse took up residence at the Régina, the former Hôtel Excelsior, built in 1895, a hotel long popular with British high society, where Queen Victoria herself had stayed. It had retained its stature as an immense palace, proudly dominating Nice with its

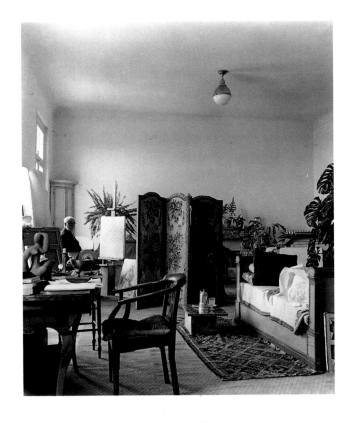

Matisse ascended the heights of Cimiez and settled down in the former Hôtel Régina, converted into apartments.

ABOVE
Pierre Boucher, Henri Matisse in his studio in the Régina.

down like one of the rich pensioners who spend the winter on the Riviera. He bought his new residence based on an architect's drawing, and had it adapted to include just a single studio this time, but a very large one. It measured approximately ten by ten yards, with three large French windows opening onto the grounds, inviting one's eyes to gaze out toward the sea.

Birds also featured in this large apartment. There were as many as three hundred in two huge aviaries: waxbills, cardinals, Japanese nightingales, female parrots, blackbirds The white pigeons and doves were even allowed to fly around freely. As for foliage , he had a real winter garden, complete with a sophisticated watering system. Francis Carco described it as "a kind of brushland." Matisse laughingly referred to it as his farm.

Lydia, of course, was involved in the move. She remained with Matisse, still serving as his assistant, housekeeper, and nurse. She assumed responsibility for running the house and the business affairs of the man she still called the "boss," while he plunged ever deeper into his work, showing but a negligible interest in household matters and administrative tasks.

magnificent lobby, solid columns, its vast staircase, and breathtaking grounds, but it had been converted into apartments two years earlier. The painter, who liked to say he could easily live like a monk in a cell providing he had something to paint with, settled

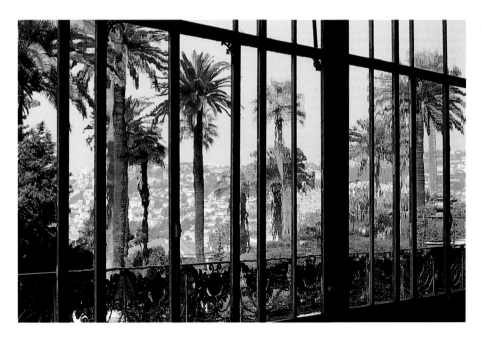

Matisse now overlooked Nice. His windows were still turned to the full light of the south. And with the increase in height and age, he himself took on a new lightness as well.

Maurice Bérard,
La Chambre Claire,
Hôtel Régina, Nice, 1941.

In a photograph by Pierre Boucher, we can see the room that served as his studio, with its Empire bed covered with cushions, a work table with a small sculpture standing on it, an armchair, a large screen, a coffee table with a glass and carafe in front of the bed. Every item seemed to form part of a whole. At the back of the studio was a fireplace with a reproduction of a statue of the Cyclades. The painter himself is standing with his back turned to the window, in front of an easel on which stands a half-sketched canvas. Another photograph shows the painter's bedroom, with its balcony overlooking Nice. There is a row of cactuses, a brick chimney with a fertility sculpture, two African masks nearby, a heavy, inelegant table, and countless drawings pinned to the wall.

Matisse's furniture had hardly changed. He became fondly attached to the objects that he had owned

so for long: armchairs and other more or less comfortable seats, the small Moroccan table, pots, ceramics, the large, upright mirror, set on the floor, in which his models were reflected. In his bedroom, he had put up wallpaper with large floral patterns, as he had in his previous homes. The critic Pierre Courthion, who came to see him in July 1941, found the master "in a pair of tea planter's pajamas," smelled "a perfumed warmth [that] entered through the windows," and was stupefied by the giant aviary with its "strident singing" of birds from all over the world. He noticed that the window of the small studio looked out over the grounds of an orphanage where the nuns would take advantage

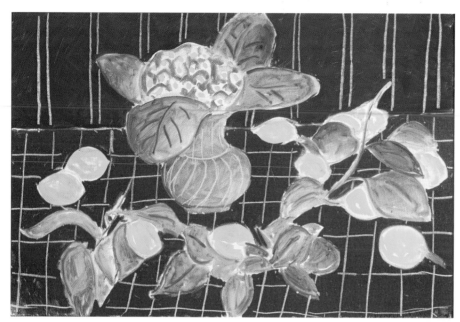

"After four sessions I have completed a sleeping figure begun in January a year ago, and I have a still life which is not yet finished after thirty sessions, and since my return to Nice I have been working every day. It is certain that our constant worry is far from beneficial to the unconscious labor that continues even when you are no longer in front of the easel. One again, you must wait," Matisse confided to Bonnard in 1940.

LEFT

Citrons et saxifrages, *1943.*

Lucerne, Rosengart Collection.

of the shade of a eucalyptus tree, and described the ambiance in which the painter worked: "Among the furniture in the large studio I recognized the artist's cherished objects which I have seen depicted in his paintings using my magnifying glass, his fetishes: lemons set on X-shaped seats, dried oranges on tables, bouquets of lilies, seashells, vases with various necks, and at the back, above the cactuses, a liana jungle."

Matisse became increasingly reclusive and scarcely ever ventured into town. He kept up the rhythm of his work, interrupting his schedule only at midday for lunch and the hour-long nap necessitated by his insomnia. As a treat he would take a stroll for an hour or so in the Régina's gardens, or occasionally, perhaps, in the pleasant grounds of the monastery. He painted Tamara as dancer in a Persian dress. He also painted Micheline, Graciella the Guatemalan,

and especially favored Nézy-Hamidé Chawkat, a sultan's granddaughter who had dazzled Matisse when he first encountered her in the street, accompanied by her governess. He asked her to pose for him and she accepted, but insisted on the presence of her chaperone. He dressed her in a Rumanian blouse. He sketched and painted her as the "sleeper," working for nine months on what was to become one of his most famous canvases: *Le Rêve.*

But was there still time for dreams? War suddenly appeared imminent as Matisse left for Geneva to see an exhibition of the masterpieces of the Prado. It was August 29, 1939, the end of the summer, that time of the year when he would normally still be in Paris. That year in Paris, he put up at the Hôtel Lutétia, his new Parisian address for the previous few years, ever since Amélie decided no longer to share his life. He attended the opening performance of

L'Étrange Farandole, a ballet by Léonid Massine, inspired by Matisse's work. He painted near the Alésia quarter of Paris, in a studio which had been loaned to him, according to Wilma Javor, a Hungarian model. He returned from Geneva in haste, boarding a train for Paris without even taking the time to view the canvases which had been the very purpose of the trip. He spent a month in Rochefort-en-Yvelines, with Lydia, painting a little bit and awaiting the outcome of events. As it turned out, the war did not break out, so he returned to Cimiez and went back to work, remembering, perhaps, what he had been told by the minister during the preceding conflict: during such troubled times, a painter should, first and foremost, paint. In the month of November, he painted a woman in a surprising costume, a sort of Marchioness Louis XV in a dress with a red sash that opened onto a striped blue undergarment. And he christened this canvas *La France*.

Was it the strange atmosphere of a weakening Europe, trying not to break out into full blown war, that made Matisse want to leave on a trip? Was it age that made him increasingly impatient, fearful that perhaps one day it would be too late to travel again? Whatever the case, he yearned to rediscover that haven of space and light he had found long before, first in Morocco, then in Tahiti. He thought of Algeria, just on the other side of the Mediterranean, which he had visited unsuccessfully some forty years earlier. Or even Brazil. Brazil appealed to him because he had met the manager of a maritime company, who offered him a one-month cruise at a substantial discount. Passport in hand, he booked a ticket and called on his tailor in Paris to be fitted with a suitable wardrobe. But the possibility of war turned into reality, and everything was in question. Matisse decided to venture south to the Gironde, where his art dealer offered to put him up, but he did not settle there. He continued on instead to Saint-Jean-de-Luz, where he rented an apartment in Ciboure, on the harbor. He went to

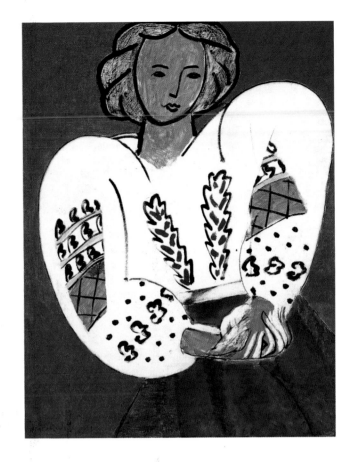

"*A work must bear in itself its entire meaning and impose it on the viewer before he even knows the subject,*" *remarked Matisse.*

ABOVE
La Blouse roumaine, *1940.*
Paris, Musée National d'Art Moderne.

Saint-Gaudens to paint the peaches, but was driven out by the advancing German forces and finally returned to Nice and the Régina.

Pierre Bonnard was in Le Cannet at that time, not very far from Nice, but communications were difficult. There was no gasoline for cars and it took nearly a day by coach and train to cross the few kilometers that separated the two friends. So they exchanged letters. Their correspondance shows that they were both equally faithful to painting, a painting based on sensitivity, intimacy, and joyful lyricism which they never ceased to share, although each had his own distinctive style.

Let us not think that Matisse was indifferent to the turmoils of current events. But his duty was to paint, in the same love, the same light, and the same beauty, so as not to give way to despair.

OPPOSITE
Petit Nu à l'hortensia
bleu, *1959. Private collection.*

Bonnard painted more delicately compared to the loose, free manner of Matisse. They expressed mutual concern for the future of their country. And Matisse painted *Le Rêve*, a work full of poignant nostalgia, the fruit of a style of painting that responded to the hardship of current events and world madness by providing a stark contrast; it exuded grace, luxury, calm, and voluptuousness, those more feminine attributes which he had always strongly defended, which now seemed to him to be more essential to convey. It was his way of sus-

taining optimism. By not giving in to despair he could continue to believe, in spite of everything, in art and in his painting, which had been, and now had to be, his reason for living. He wrote to his son, Pierre, that he was striving to hang onto his work, but was finding it difficult to work as he really would have wished. His intention, for example, was to paint still lifes, flowers, and fruit, but concentration was almost impossible and he had difficulty relating to the inanimate objects that he himself had to breathe life into with his own emotions. So, mornings and afternoons, he would sketch and paint pretty, out-of-work film extras. In this way he kept more or less to his original project because he would spend the day with flowers and fruit around him in such gentle contact that he was hardly even aware of it. The way he had arranged his studio meant that it did not lack expressive areas, that he observed from time

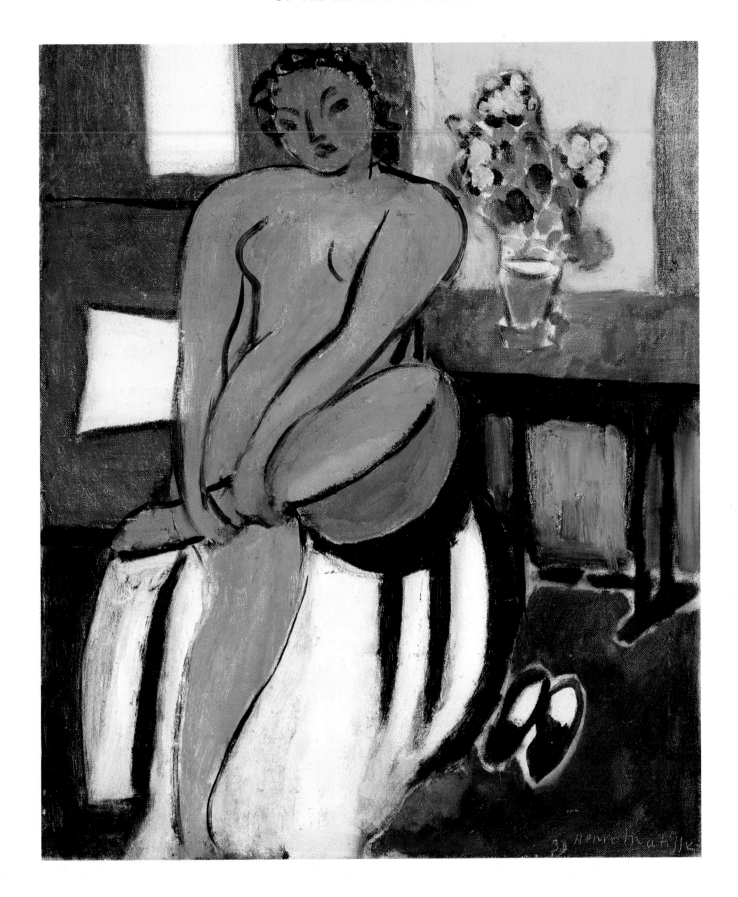

to time, and wanted to paint, but could not paint—because Matisse, in order to paint, needed "love at first sight." This tension and waiting, which he experienced so acutely, would drain him of all his energy.

At the end of 1940, Matisse, who had always been a great connoisseur of seafood, painted oysters. He explained that this was his way of re-centering himself after a long period of work and research. He had made great progress with the decorative-style painting of which he was a pioneer. He expended an enormous, sustained effort to abstract painting from reality, to pass from impression to form, and to transform his emotion into a canvas. This was a process of "abstraction," he remarked, and he thought that he had reached the bounds of what was possible for him at that time.

This had been accomplished "by dint of meditation, and bouncing off the various planes of elevation and reduction." At that time, therefore, he could not improve; he could only repeat. Perhaps it would be better to stop and start again afresh, or at least find a change of direction and lifestyle in order to experiment, if only momentarily, with something different. He wrote to his friend, the Rumanian painter Theodor Pallady, in a letter quoted by Pierre Schneider: "I have therefore disciplined myself to concentrate on ordinary, ethereal subjects, and as a result, I have come closer to the very substance of things. And so I paint oysters—the taste buds are important in this instance, my dear fellow—even a reproduced oyster must remain in essence what it is: an oyster." He began to concentrate more on

RIGHT
Hélène Adant,
View from the Régina.

Matisse's whole life and work were but a single struggle for harmony. Even his poor health could not stop him. Melancholy and pain did not have carte blanche in the painter's life. Like the countless birds that were so many melodious companions for him, his song would never die.

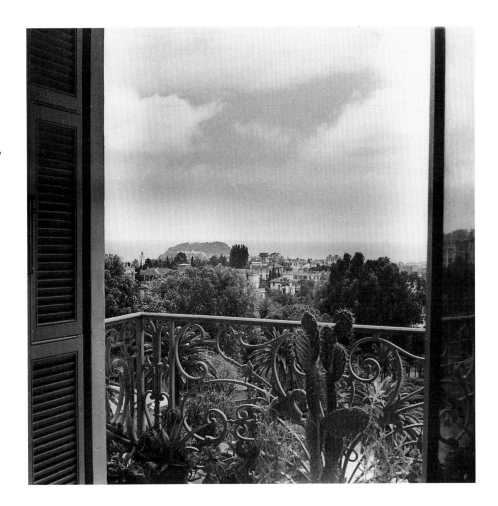

pictorial accuracy and turned his attention back to the Flemish realists and the still lifes which had influenced him so strongly in his early career. The Dutch rendering, as he called it, was in stark contrast to his more recent preoccupations. He was on his third canvas on the subject when he confessed to his friend the inescapable dilemma that he faced: "Of course, while denying it, I stress the background of the room and the immediate surroundings." For no matter how much he wanted to control the oyster motif, he could not tear it away from the interaction of all the elements present within the same space, because essentially what Matisse painted was always a certain space, and even here he could not prevent himself from doing so. Nevertheless, he ultimately succeeded, he said with some degree of satisfaction, in finding a new interrelationship between the main subject, the oysters, and the

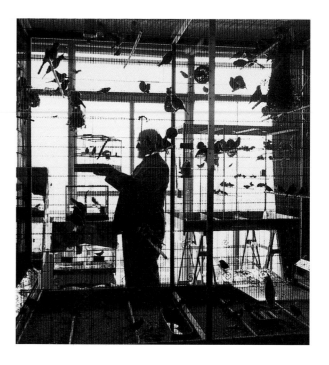

Roger Schall, Les Volières,
Hôtel Régina, Nice, 1958.

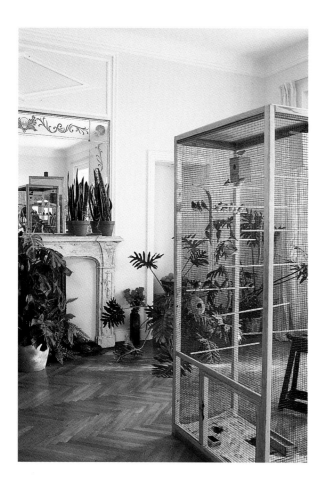

painting—that is to say, by translating the "gustatory sensations" into the "visual essence of taste." Thus he painted *L'Intérieur aux huîtres, table bleue et rose; La Table au plat d'huîtres; Huîtres, table verte; Huîtres et fauteuil en bois; Huîtres et tulipes.* But oysters quickly lose their luster, hardly surviving for more than two days, at best, as a model. Lydia was surprised that Matisse would not eat them after he had finished painting them. No doubt he liked them very fresh!

At the age of seventy-one, this man who had always had a delicate stomach fell ill, and even the doctors had difficulty agreeing on a diagnosis. They discussed surgery, and it was in Lyons, on January 17, 1941, that he put himself in their hands. His recovery was complicated by two successive heart attacks, and the sisters acting as his nurses jokingly remarked that he had been "brought back from the dead." Which was exactly what he felt himself. He was aware that he could and should have died, and now had to regard the remainder of his

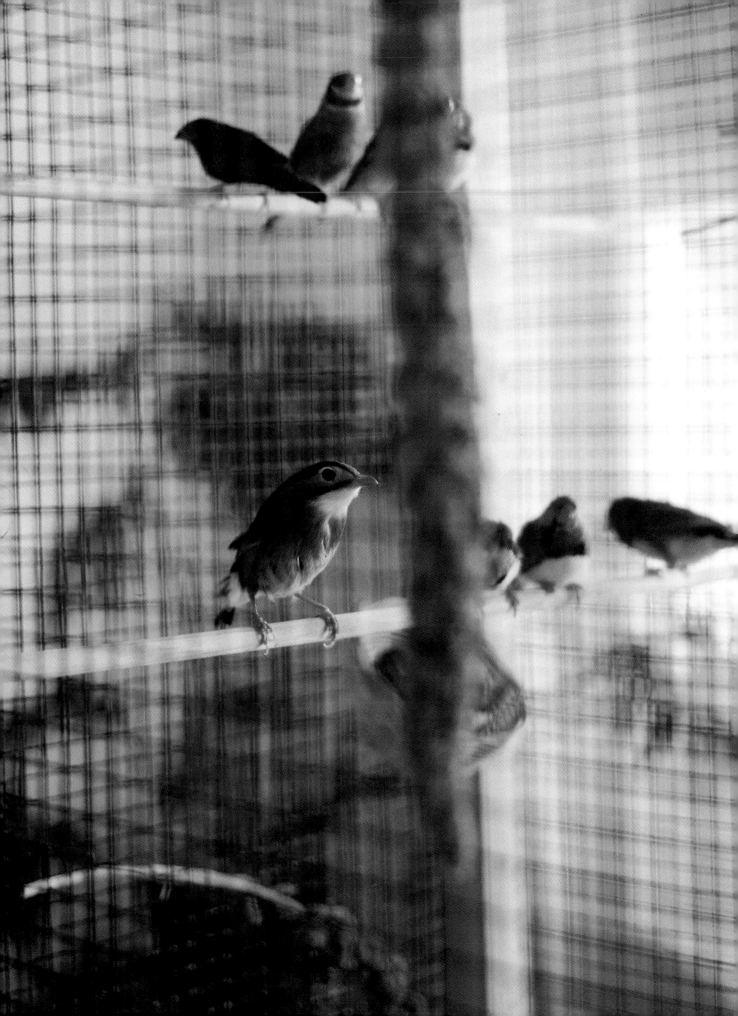

life as an unexpected gift. He felt suddenly lighter, younger, and clearer of mind than ever. Unfortunately, influenza forced him to remain in Lyons, shut up in a hotel room, and it was only on May 23 that he returned to Nice, greatly weakened. He had to wear a corset to support his abdominal muscles, and could not remain upright for long. As a result, he would now spend most of his time between his bed and a wheelchair. He quickly returned to work, though he was careful to conserve his strength. Disturbed by his recent ordeal, he became introspective and produced a large volume of what he called "sketches based on myself."

The beautiful Nézy (his "little dream princess") was still posing for him. Janie Michels came by once or twice a week, but a model only had to have a "vacant expression" for the session to fail altogether, and for the painter to lapse into depression as he wrote to his old friend André Rouveyre. A trip to the cinema with Lydia tired him out.

Drawing comforted him, as did poetry. Matisse had promised the publisher Albert Skira that he would

illustrate a collection of poems by Pierre Ronsard. The texts that were to compose this anthology he chose himself, according to the emotions that they aroused in him. With that vivid enthusiasm he had always shown for the decorative arts, he deliberated on the typeface best suited for such a publication: Elzevir, Cochin, Plantin, Garamond? And he continued to make countless drawings of Nézy, Lydia, and Janie, who became, respectively, Ronsard's three Muses: Cassandra, Maria, and Helen. He liked these love poems as he did the faces of these women, and wrote to Rouveyre: "My appreciation of freshness, beauty, and youth in respect of things like flowers, a beautiful sky, or an elegant tree has remained the same for the past thirty years; why should it change when applied to young women?" Pursuing the theme, he rewrote the list of the four elements and added a fifth: "What could be more delicious than Love when one knows how to use it (like Fire, Water, Air and Sea [sic]) as long as one keeps in perspective the role of she who provokes it?" We could interpret from this that the attraction that Matisse felt toward to those young women whose gift of beauty enriched his paintings was not entirely sculptural. He had long been aware that his art was the product of "sublimated pleasure." But war is not conducive to such projects, and the book was only published in 1948.

Louis Aragon, another poet who shared a fondness for Ronsard, happened to be in Nice. As a Communist and an undesirable in an occupied zone, the writer had moved into the Ponchettes quarter with his muse and wife, Elsa Triolet. He was also a secretly involved with the Resistance, although not to any dangerous degree. He had always admired Matisse, whose bright, classical, and ambiguous painting was not unrelated to his own conception of a poetry that willingly cultivated traditional rhythm and rhyme, without being voluntarily obscure, but which was less simplistic than it appeared. He even borrowed Matisse's name in 1919 for

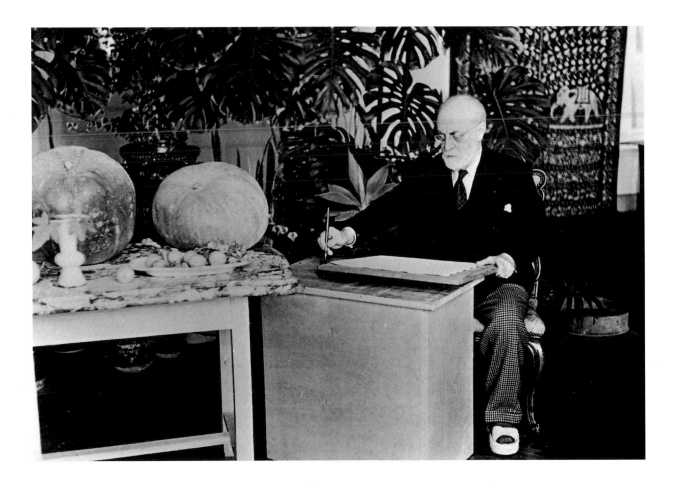

Hubert de Ségonzac,
Henri Matisse drawing,
Hôtel Régina, Nice, 1940–41.

one of his heroines. Aragon wished to consult Matisse about the review *Poésie 41* that Pierre Seghers had published in Algiers, in which he wished to include three drawings by the artist. So he went to see Matisse at "Sleeping Beauty's Palace," in the breathtaking Régina: ("Oh columns, Oh great, empty staircases like strong shoulders"). In the tranquility of this building, which was virtually uninhabited during this time of war, he was amazed at "the calm of this man who was well aware that he was alive due only to a reprieve." At their first meeting they spoke for four hours. From then on, Aragon returned almost every day because

Louis Aragon, forced underground by the Occupation, was in Nice. He had come to see Matisse, and took from him a lesson in wisdom and poetry. He admired that joyful world which Matisse painted–a world in which he would have liked to live, and which would long haunt him and inspire his writing.

RIGHT
Fleurs de la Saint-Henri, *or* Fleurs et figures, pot arabe, *1959.*

Chicago, private collection.

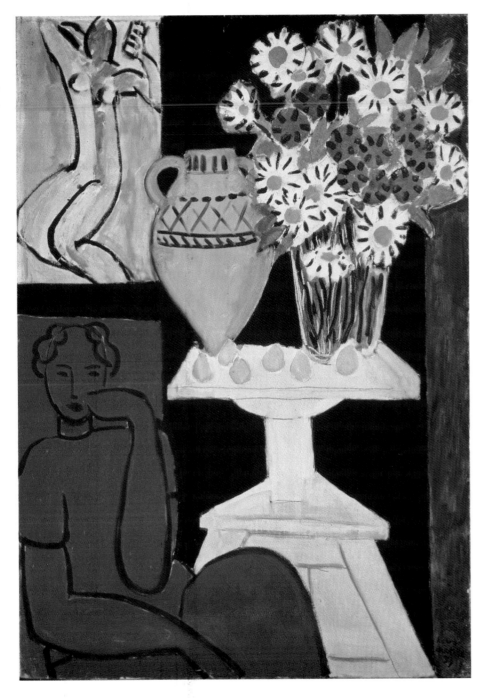

they had put together another project: a text by Aragon to accompany the publication of Matisse's drawings (*Thèmes* and *Variations*)—the ones he sketched with charcoal or traced almost in a single line, with a pencil or pen, covering the walls. There were perhaps a hundred of them, thumbtacked in perfect order in "that tall, bright room overlooking Nice, the sea, the palm trees and birds." Aragon found there something as beautiful, as significant in the history of art as the caverns where prehistoric artists drew the first buffaloes, or the cave in which young Giotto made drawings, which Cimabue found purely by chance.

Objets et vase chinois,
1941. Private collection.

Aragon looked at a drawing and could quickly perceive the heart of Matisse's creation, in one of those instant rapports that sometimes spring up between painter and writer. He expressed this in a very beautiful sentence: "Before his model, whether it be a woman or a flower, Henri Matisse's drawing is powerfully endowed with the purity of spirit." Yes, Matisse was that painter for whom everything began with "love at first sight" (even for a still life, it had to grip his heart), but one who had the talent of sublimating his desire by exalting the subject. Aragon, like Matisse, was in tune with his feminine side and, perhaps because he had

been raised without a father, he admired that the greatest quality of this artist, who fascinated him and to whom he felt so close, was a sure and highly delicate sense of the interaction of things. For example: "the transition from fabric to flesh, the meeting of those things that slip in the garments of women, and of the woman herself, blouse straps and ribbons, and how they take shape in the small of the back, or close to the armpit, or the breast." It was also his way, as we have already mentioned, of living among objects as if in a wash of motifs that came to life to inspire the painter: "Wander through the rooms in Cimiez in which those objects are scattered. The plants, fabrics, marbles, and tapestries which reappear in the master's canvases (…) This was his real palette, a palette of objects with which chance and the painter's imagination play at leisure, until the relationship between a piece of fruit and a canvas, between a leaf and a woman would appear, that Matisse had to capture forever."

Palette. Aragon insisted on this word even though it might be overused, since it is normally used in its secondary meaning, to describe the group of colors favored by any one painter. But the word came to him less in front of the objects themselves than in front of a gathering made for a photograph. Aragon wrote a text in homage to Matisse, entitled *La Grande Songerie* (later to be included in *Matisse Roman*), and received from the painter an astonishing snapshot as a record of the objects that had featured significantly in his life and work. Grouped together in several neat rows were glasses, cache pots, cups, and other ceramics, precisely arranged on a table alongside the Arabic pedestal so often depicted. Other photographs showed Matisse's armchairs, wooden or covered with fabric. One particularly astonishing piece was a Venetian baroque chair whose seat and back were two large scallop shells. The painter had searched long and hard before finally discovering it in an antique shop. It had real character, remarked Aragon, a bit grotesque, perhaps,

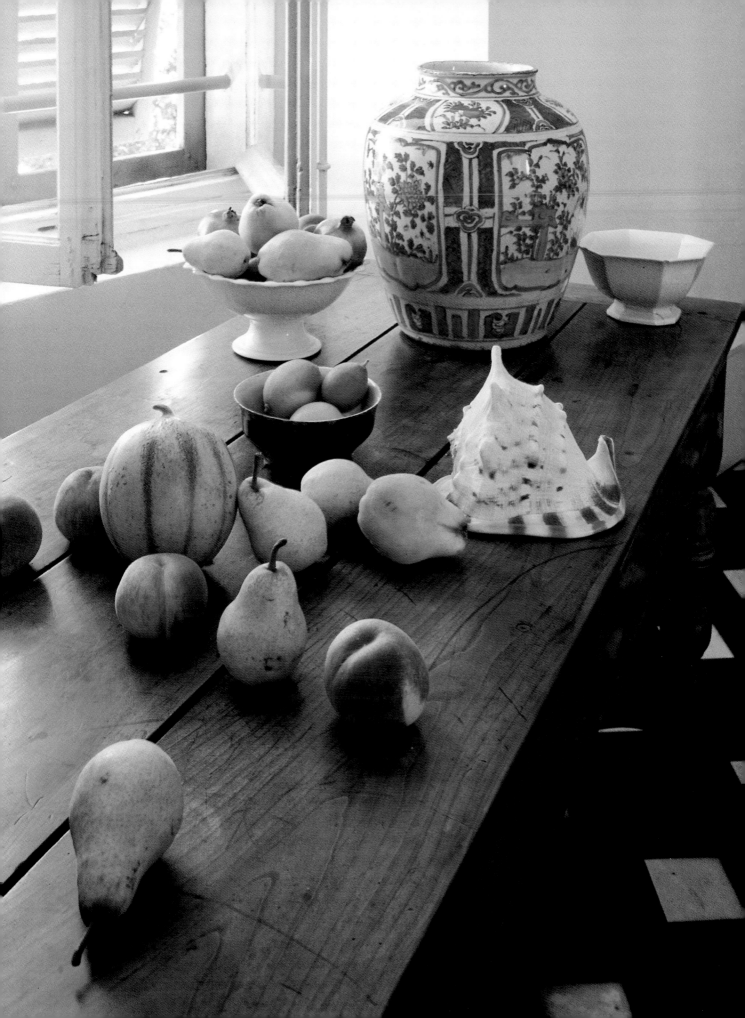

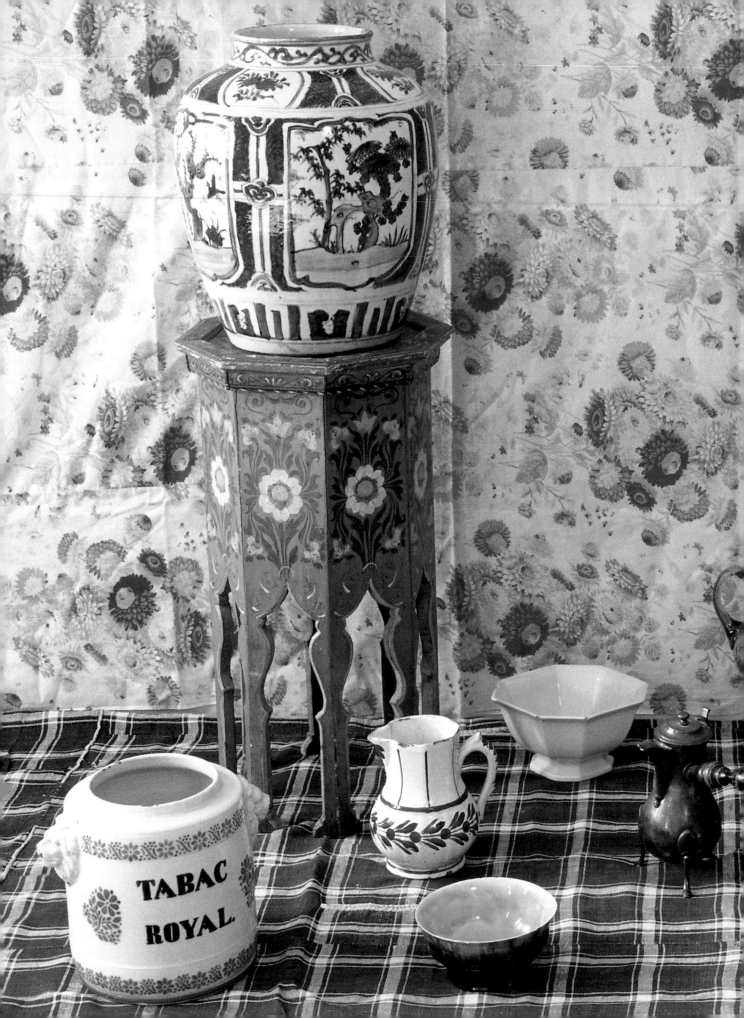

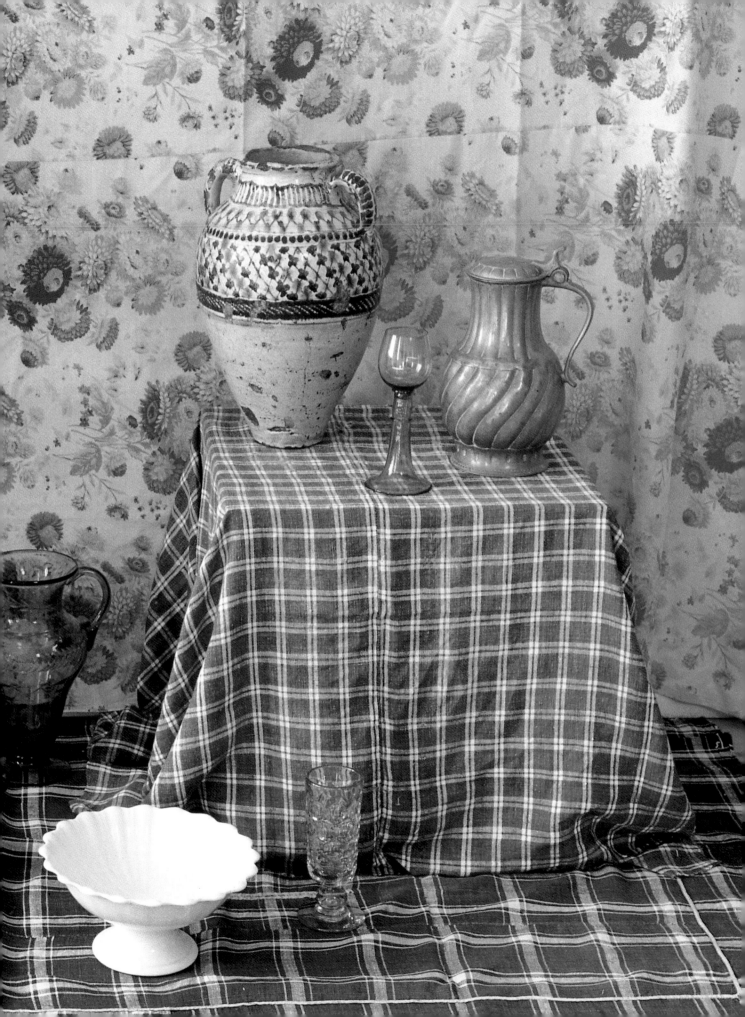

but incredibly dramatic, with a suggestion of metaphysical anguish! Here was an object on which it would indeed be possible to heap an excess of love. Matisse, a short time later, mentioned "the friendly presence of his armchairs" to Pablo Picasso. It was his gift of doves to Picasso that gave rise to the symbol adopted and made famous by the Catalan painter.

Rather than palette, Aragon explained, one should have said, "object glossary": "Does one call the pieces of a chess set a palette? I see, nevertheless, Matisse's hand hovering, and he is going to advance the Rook (the Tabac Royal), the Queen (the statuette), or the white Bishop (with its narcissi), if not the black Bishop (the small, spiraled pewter pot). The chess pieces are not simply colors with which one paints one's game, but rather the words of the already constructed sentence, of the thought processes that lead to

the discovery." The canvas was, in its own way, always a game of chess.

Matisse's very existence, "this painter for whom all is sun" as Aragon said, was essentially a long chess game replayed over and over with Matisse pitted against the darkness. The man himself was not as knowable as his painting suggested because he made it a rule, an ethical as well as an aesthetic rule, not to let his personal concerns, whether heartaches or poor health, reflect in his work.

This man who brought such joy to art, whose paintings and drawings conveyed a serene confidence in the world and its animate and inanimate objects, was an elderly, sick man. In the days when Aragon was a regular at the Régina, Matisse suffered from abdominal pains and gall stones. The poet was a witness to his pain which became obvious despite the efforts he made to conceal it. Sometimes it washed over his face while they chatted about art and poetry in the studio. This was the reason Matisse moved and traveled little. During that entire winter of 1941–42, he scarcely left Cimiez. He rented a car occasionally and ventured into town to La Coquille for lunch with Aragon and Elsa. Aragon was not quite sure of the name of the restaurant when he wrote his account, but it was the one on rue Masséna. Sometimes he went with Lydia to the home of the Aragons to enjoy a goose liver that had been sent to them, or one that Elsa had cooked herself. Matisse never complained. His paintings projected an optimism which prompted Aragon to say: "He himself is the gift that he has made to our sick world." The poet had become increasingly involved in the Resistance, so much so that he would soon have to leave Nice. Louis Gillet, an art historian who passed through Cimiez at approximately the same time, came out beaming from his first interview with the painter and rejoiced: "I have just seen a truly happy man."

In May 1944, however, Matisse was devastated to learn that his wife Amélie and his daughter Marguerite

Opposite
Nature morte "diapason,"
*1941. Paris, Musée National
d'Art Moderne.*

Above
Pot d'étain, études,
1942–43. Private collection.

that would make life easier for the observer, not screens onto which he could project his own inner torment. He had to turn his back on the horror in order to celebrate life and all the potential happiness it holds.

Monique Bourgeois came to look after the ailing Matisse on September 26, 1942. He needed help at night, for he liked someone to read to him as he was still unable to sleep, and his eyes were tired from working. He also needed someone to help him fasten his corset if he needed to get up, and sometimes he had his legs massaged, for his circulation was poor. Monique Bourgeois also helped him prepare his gouaches, following a method he had perfected for working in his bed. He drew the color directly by cutting it out of a sheet of painted paper. He did drawings of her, and paintings (*L'Idole*) and they became friends (which he called "flirting"). He had a special desk built, a table which came across the bed so he could work without

had been arrested for aiding the Resistance. He wrote to Charles Camoin that this was "the greatest shock in [his] life." Faced with this double tragedy, he reacted in his own inevitable manner, the way he had done ever since he began to paint: he immersed himself in work. His way was not to give in to sadness, nor to start on the slippery slope to despair. Amélie and Marguerite pulled through this trial. In January 1945, Marguerite was lucky enough to escape from a deportation convoy and returned to spend a few days with her father. She told him what she had been through, and Matisse wrote to Rouveyre that he was "caught up in the whirlwind of the agonizing memories of [his] daughter's captivity." He had to build protective barriers against the painful onslaught. He had had to build defenses to be able to paint, so he hoped that the resilience he had developed as an artist would protect him now. He had to paint—in spite of everything, in spite of the war, in spite of illness, in spite of the suffering of his family—pictures of tranquility, paintings

"The object is an actor: (…) an object can play a different role in ten different paintings," said Matisse.

ABOVE

Hélène Adant, Objects that have served me my entire life . . . , *1946.*

getting up and, settled in this way, he continued to receive his models.

Monique became Sister Jacques Marie, a Dominican nun, and was responsible for the Chapelle de Vence. After asking advice of the artist, who was still a friend, she then enticed him into the adventure of his later years, when he became the master craftsman of an edifice which was the great accomplishment of his life's work. This, at least, is how he talked about it and devoted himself to the work, and most critics today agree. Throughout his life he tended toward simplicity, the ultimate, essential language of painting, in which

any personal messages would be absolutely universal, in which all the artist's work would be resolved in perfect humility. To his contemporary, Bonnard, another great, discrete artist who had also traversed the half-century engaged in painting, in the post-Cézanne period and withdrawn from the conflicts of modern art, he wrote in all sincerity: "Giotto is for me the summit of my desires, but the road that leads to an equivalent in our time is too long for a single life."

The work for the chapel kept him busy for a long time, at the Régina, in Vence, where the bombings of Nice had incited him to seek refuge (in a Villa called The Dream), then again at the Régina, to which he returned at the beginning of 1949. The apartment had hardly changed, for Françoise Gilot, who came at that time with Picasso (Matisse served them dates and pastries), could still describe it as the "metamorphosis chamber." "The philodendrons, tables, the rocaille

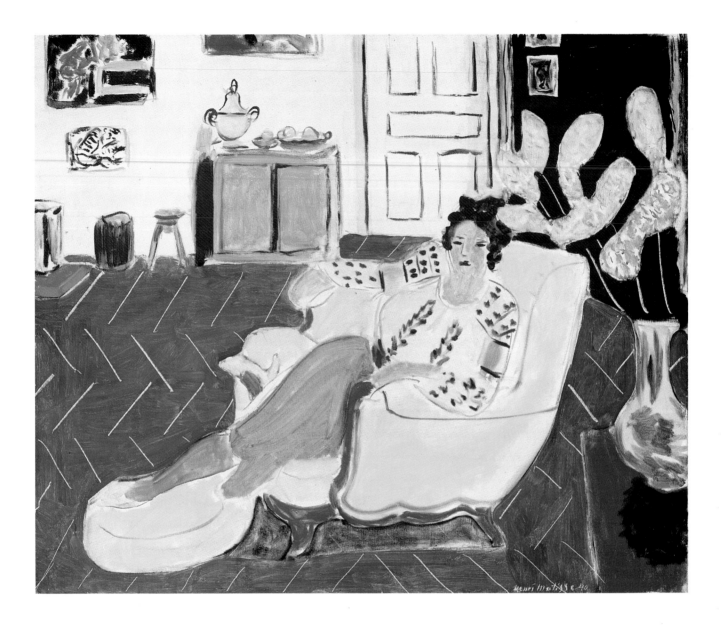

armchair and other famous objects took on a dream-like quality in the shadows, like phantoms in the corridors of a disused theater, until they reappeared in the rarefied atmosphere of a painting, allowing the visitor to see that art possessed more energy and consequently more physical reality." This world Matisse created at the Régina was still discretely reigned over by Lydia, of whom the same visitor wrote a description full of admiration: "(...) almond-shaped eyes, a straight, classical nose, curved lips, a strange expression mingled with distant reserve and sensuality, with a uniquely mysterious aura." She was Matisse's nurse and friend, and remained his model right up to his last drawings, in November 1954, which Matisse sketched just before he died.

Other models, pretty young girls, still continued to come to the bedroom-studio where Matisse worked until the end. Jacqueline Duhême, a young girl keen on drawing, and a great admirer of the painter, wrote to him and was invited to meet him. He fell quickly under

her charm and she was taken on as "studio assistant." She was given board and lodging, tasted the dishes prepared by the Polish cook, provided Matisse with *palmiers*, the pastries he particularly liked, drank champagne and Alsace wine with him, ate cod brandade and potatoes cooked in a *diable*. Later on, when she recounted openly her life as a socialite artist in which she met many famous people, she bore witness to a cordial, warm Matisse, who always worked so hard, was a bit obsessive concerning the exact arrangement of each object, and was still young at heart despite his age and ill health.

Few artists devoted themselves to their work the way Matisse did, but the most extraordinary thing is that he did it without asceticism and with a perpetual love of life and perfect confidence in the world, in the world of the here and now that his work never ceased to magnify. For forty years, during the most important years of his existence, his favorite setting was the Riviera, which death itself, on November 3, 1954, would not force him to leave, since he was laid to rest forever in the cemetery at Cimiez.

"The artist or the poet possess an inner light that transforms objects to create a new world, one that is sensitive and organized, a living world that is in itself the infallible sign of divinity, of the reflection of divinity," stated Matisse.

OPPOSITE
Jeune Fille dans fauteuil jaune, parquet et lilas bleu, *1940. Saint-Jean-Cap-Ferrat, Maugham collection.*

RIGHT
Hélène Adant,
Le Vase étrusque.

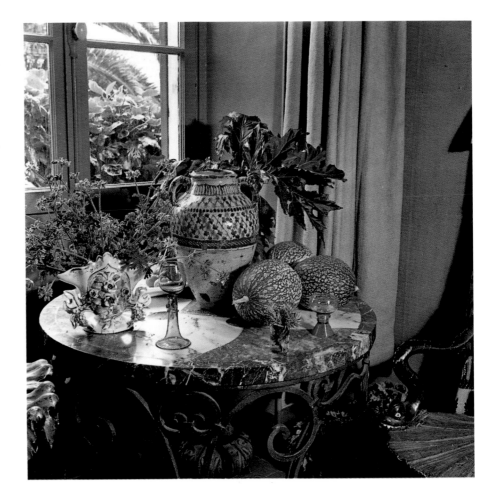

Hélène Adant, Henri Matisse drawing.

From Fauve to Dove

In a letter to Henry Clifford written from Vence on February 14th, 1948, and quoted by Lydia Delectorskaya, Henri Matisse shared his fears and the anxiety he felt at the thought of his responsibility toward young painters: exhibiting his paintings could well have "a more or less harmful effect on young painters" due to the paintings' false impression of "apparent facility." He continued: "I have always tried to hide my efforts, I always wanted my paintings to have the lightness and gaiety of springtime, which never shows a trace of the work it required." And he was perfectly successful in this—to such an extent that he sometimes gave the impression that he cared little of the turmoil of the world and all the human suffering around him. But it would be wrong to take as indifference, or even selfishness, what was not an expression of historical reality but a response to that reality, which required another kind of strength and courage. Matisse's painting depict happiness, *joie de vivre*, fervor—not the complacent celebration of blind luxury, the *calm et volupté* of an exotic utopia, but a formidable celebration of desire. For Matisse is no doubt the painter who has given us the most beautiful and most truthful figures of desire. Louis Aragon was right to give him the title, "the painter of perpetual hope."

Some time later, Matisse went up from Cimiez to Saint-Paul-de-Vence to have tea at the famous restaurant the Colombe d'Or. During the years he spent in Vence, he became friends with the writer André Verdet and the host, Paul Roux. He liked to sit with them under the enormous, ancient fig tree there, sometimes in the spring or in the autumn. Verdet, who recounted the anecdote, spoke of the "smiling kindness" of the painter, who nonetheless always kept a slight distance "like an important, official person." Doves flew around, taking off and alighting again, and Matisse watched them. He said to André Verdet: "So many times, when I leave here and go back to the studio in Cimiez, I carry on being the dove and following its flight!"

Although an octogenarian, Matisse was still incredibly nimble. This "sensation of flying," he said, helped him with the work he was doing. This was the paper cut-outs, his drawing with scissors that he favored in his later years. He had achieved the great simplicity he aspired to for so long, and which he knew could only be granted to him as the accomplishment of a whole life's work. Far from the ardent spirit of his romantic youth, more passionate than his biography suggests, Matisse, who half a century earlier had caused a scandal with his wild fauvism, who had made color scream, was now more like a dove, that angel of arabesques: "The successive flights of the doves, their orbs and curves, drift inside me as if they were flying in a vast interior space."

Henri Matisse was not born a dove. He became one, by making himself lighter, by simplifying, recognizing himself in the space and light in which things gain in savor what they lose in weight. This space, this light, was not just any space, any light; they were the space and light of Nice, and of the so aptly named Cote d'Azur.

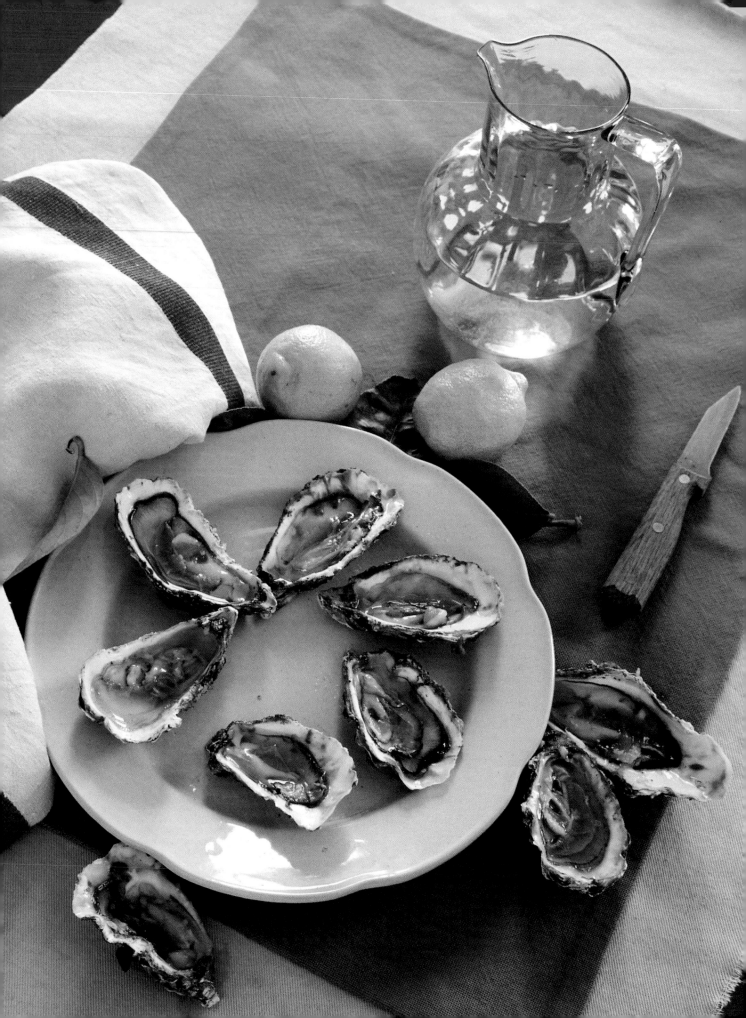

Recipes

"There was a Polish cook, a woman in Matisse's home who made excellent dishes and cakes."

J. DUHÊME

Nature morte aux huîtres, *1940.*

Basel, Kunstmuseum.

Soups

Purslane soup

Serves 6

2 onions; 3 large potatoes; 2 bunches purslane; 3 tablespoons olive oil; 2 teaspoons coarse salt; 12 small croutons; 2 egg yolks; 1 cup heavy cream; freshly ground black pepper

Peel and chop the onions. Peel the potatoes and dice into large cubes. Wash the purslane and set aside about 30 leaves. Trim the stems to a length of about 2 inches. Heat 1 tablespoon olive oil in a large saucepan over low heat. Toss in the onions and stir for several minutes until they become translucent. Pour in 8 cups water. Add the potatoes, the trimmed purslane, and the salt. Bring to a boil, reduce the heat, half-cover, and simmer for 40 minutes.

Meanwhile, blanch the reserved purslane leaves in boiling water for 2 minutes, and set aside. Fry the croutons to a golden brown in 2 tablespoons olive oil. Set aside and keep hot.

In a bowl, blend the egg yolks and the heavy cream.

Pass the soup through a vegetable mill using a fine mesh or process briefly in a blender. Pour the liquid back into the saucepan over low heat. Quickly stir one ladle of soup into the egg yolk mixture. Pour the mixture back into the soup in a thin stream, stirring constantly, until the soup thickens. Immediately remove from the heat, as the soup must not boil after the addition of the egg yolk mixture. Add the purslane leaves, and freshly ground pepper to taste. Serve immediately in a tureen, sprinkled with the piping-hot fried croutons.

Note: Watercress can be substituted for purslane if the latter is not available.

Cream of pumpkin soup with chervil

Serves 6

1 quarter pumpkin (a generous 3 pounds); 3 tablespoons butter; a pinch coarse salt; 2 cups milk, scalded; 2 cups crème fraîche; freshly ground black pepper; freshly grated nutmeg; 20 small stale-bread croutons; 1/2 bunch chervil

Peel and seed the pumpkin and cut the flesh into small pieces. Melt 2 tablespoons butter in a stockpot. Add the pumpkin and mix well, Add a glass of water and a generous pinch salt.

Cover the pot and simmer about 20 minutes over medium heat, stirring from time to time, until the pumpkin pulp is reduced to a purée.

Run the purée through a vegetable mill or food processor. Pour back into the pot, then add the scalded milk and the crème fraîche. Bring gently to a boil over low heat, stirring constantly. Season to taste with salt and freshly ground pepper, then sprinkle with grated nutmeg. Simmer approximately 15 minutes. Meanwhile, brown the croutons in the remaining butter.

Pour the hot soup into a tureen. Sprinkle with chervil. Serve with croutons, a small cup of crème fraîche, and freshly grated Parmesan cheese.

OPPOSITE: *Cream of pumpkin soup with chervil.*

Cream of onion soup

From Matisse, according to his correspondence
with Charles Camoin in 1941.

Serves 6

3 large onions; 3 tablespoons peanut oil; 4 tablespoons butter;
6 cups whole milk; coarse salt; freshly ground black pepper;
freshly grated nutmeg; 10 small, thin slices stale bread; 1 cup
freshly grated comté cheese

Peel the onions and cut them into thin slices. In a large
stockpot, heat the oil and butter over medium heat.
Add the onions and stir until golden brown.

Meanwhile, bring the milk to a boil in a saucepan.
Pour the boiling milk onto the browned onions. Sea-
son generously with salt, freshly ground pepper, and a
good pinch of grated nutmeg. Bring to a boil, then
reduce the heat. Simmer approximately 40 minutes.

In a tureen, alternate layers of stale bread slices
and grated comté cheese. Pour in the hot soup. Cover
the tureen for a few minutes until the bread absorbs
the liquid and the cheese melts. To serve, ladle the
soup from the bottom of the tureen.

Tomato soup

Serves 6

2 onions; 4 garlic cloves; 4 tablespoons extra-virgin olive oil;
9 pounds very ripe tomatoes; coarse salt; 2 teaspoons sugar;
1 tied bouquet garni (parsley, bayleaf, and thyme); 1 clove;
freshly ground black pepper; a pinch cayenne; 10 basil leaves;
10 parsley leaves

Peel the onions and cut into thin round slices. Crush
2 garlic cloves in a press. Heat 3 tablespoons of the
olive oil in a large stockpot. Lightly brown the onion
slices and the crushed garlic in the oil. Cut the toma-
toes into quarters and add to the pot. Stir for several
minutes. Season with salt and add the sugar, the bou-
quet garni, and the clove. Bring to a boil, then reduce
heat to a light boil. Simmer about 15 minutes. Remove
the clove and bouquet garni. Blend the soup in a vege-
table mill using a fine mesh, or use a food processor.
Pour back into the stewpot, then add boiling water until
the desired consistency is reached. Simmer for another
20 minutes. Season with freshly ground pepper and a
pinch of cayenne. Chop the basil and parsley leaves
and crush the 2 remaining garlic cloves. Place in the
bowl of a food processor with the olive oil and blend
until a paste forms. Pour the soup into a tureen, then
stir in the seasoned paste. Serve with toasted bread
slices seasoned with garlic according to taste.

144

Borscht

Serves 6 to 8

1 top rib with bone; 1 large onion; 2 cloves; 1 tied bouquet garni (parsley, bayleaf, and thyme); coarse salt; 10 black peppercorns; ½ head Savoy cabbage; 3 carrots; 1 turnip; 2 potatoes; 2 red beets, cooked; 1 pound tomatoes, fresh or canned; ½ bunch fresh fennel

Borscht.

Place the top rib in a stockpot and add approximately 8 cups cold water to cover. Bring to a boil over low heat. Skim the foam as it forms. Peel the onion and stick the 2 cloves into it. Add the onion and bouquet garni to the pot. Season with coarse salt, and add the peppercorns. Simmer for 90 minutes.

Cut the cabbage into fine strips, removing any large ribs. Peel the carrots, turnip, and potatoes, then grate coarsely. Add the strips of cabbage and shredded vegetables to the pot. Stir thoroughly and simmer for 50 minutes.

Meanwhile, peel the beets and cut into matchsticks. Grate the tomatoes and add to the soup. Simmer another 10 minutes. Add the beet sticks. Remove the bouquet garni, onion, and top rib. The top rib may be used for piroshkis (see recipe page 148), or dice the meat into small cubes and add to the soup.

Bring the borscht to a boil, then remove from heat. Chop the fennel greens and add to the borscht. Stir, and pour into a preheated tureen. Serve with a small cup of crème fraîche or with sour cream sprinkled with chopped fennel.

Appetizers

Grilled yellow peppers

Serves 6

6 yellow peppers; 12 salted anchovy fillets; 2 garlic cloves; 4 tablespoons olive oil; salt; freshly ground black pepper

Preheat the oven to 450°F. Wipe peppers and set whole on a greased baking pan. Place in the center of the oven for 25 to 30 minutes. Watch them closely and turn them to cook all sides. Place the roasted peppers in a plastic bag and seal. Cool in the bag for at least 15 minutes, then remove the skins. Stem the peppers, cut them in half, and remove the seeds. Keep the juice. Rinse the anchovies in cold water, pressing out the salt with your fingertips. Soak the anchovies in a bowl of fresh water for at least 2 hours, then dry on paper towels.

Grease the bottom of the serving dish with olive oil and arrange the anchovy fillets in a star shape. Place on top of each fillet one-half bell pepper. Peel and finely mince or press the garlic cloves. In a small bowl, combine the garlic with the pepper juice and the rest of the olive oil. Pour over the peppers. Season with freshly ground pepper to taste, but salt very sparingly (anchovies are already salty). Cover the dish and marinate overnight in the refrigerator. Serve with slices of piping-hot, toasted country bread.

Note: Both yellow and red bell peppers are sweet, and both may be used together in this dish. They keep well for several days.

Blini

Makes about 30 blini

3 cups milk; 6½ cups wheat flour (or 4½ cups wheat flour and 2 cups buckwheat flour); 3 packets (¾ ounce) active dry or fresh compressed yeast; 4 eggs; 1 cup (2 sticks) butter, plus extra for greasing; salt

Warm half the milk. Crumble the yeast into 1 cup of the heated milk until completely diluted. Sift half the flour into a large bowl. Make a well in the center and pour in the heated milk and the yeast mixture. Mix with an electric beater until the batter is smooth. Pass the batter through a fine strainer or chinois. Cover the batter with a kitchen towel and set aside to rest for 2 hours at room temperature.

Separate the eggs. Put the whites in a large bowl and set aside. Warm the remaining milk. In a separate pan, gently melt the butter, then remove from heat. Stir the warm milk into the rested batter, then blend in the egg yolks. Add the melted butter and mix well. Sift in the rest of the flour, and add 1 teaspoon salt. Mix the batter with the electric beater until combined. Pass the batter once more through the strainer or chinois. Cover with a kitchen towel and set aside to rest for 2 more hours.

Beat the egg whites with a pinch of salt until stiff. Fold one-third of the whites into the batter, stirring by hand very delicately from bottom to top. Add the rest carefully, without overmixing. Cover the batter with a towel and set aside to rest for 2 more hours.

OPPOSITE: *Grilled yellow peppers.*

Place a large griddle or two smaller pans over medium heat. As soon as they are quite hot, grease them with butter. Pour ladles of batter into each pan to form circles of the desired size. Let the blini brown 3 to 4 minutes on each side. Keep them warm in the oven, covered with a moist towel so they remain soft.

Serve the blini with a small bowl of melted butter, or sour cream or crème fraîche. Enjoy them with caviar, smoked salmon, herrings, or carp roe (tarama).

Piroshkis
Makes about 20 piroshkis

DOUGH: 1 packet (¼ ounce) active dry or fresh compressed yeast; ¼ cup milk, warmed; 2¼ cups flour; ¾ cup (1½ sticks) butter, at room temperature; 1 teaspoon salt; a pinch sugar; 3 eggs, lightly beaten, plus 2 yolks

FILLING: 3 eggs; 2 onions; 2 tablespoons butter; 1 top rib of beef cooked in borscht (see recipe page 145) or a slice of beef from the butcher, boiled; 4 to 5 sprigs fresh fennel, chopped; salt; freshly ground black pepper

Begin by preparing the dough. Dissolve the yeast in the warm milk, and set aside. Sift the flour into a large bowl. Make a well in the center, then add the butter in small lumps. Add the salt, the pinch of sugar, and the 3 eggs. Using your fingers, work the ingredients in the well until amalgamated, then begin to draw in the flour. As the dough becomes less sticky, begin kneading, adding the milk mixture at intervals. The dough is ready when it no longer sticks to your hands. Cover the bowl with a kitchen towel and set aside, away from drafts, for 1 to 2 hours until the dough doubles in volume.

While the dough rises, prepare the filling. In a saucepan, cover the eggs in water and boil for 12 minutes. Cool under cold water, then shell. Cut the eggs in half, then mash with a fork. Peel and mince the onions. Melt the butter in a frying pan, then add the onions with a little water. Sauté over medium heat until they

begin to brown. Mince the beef and place in a bowl. Add the crushed eggs, onions, and chopped fennel. Season with salt and freshly ground pepper and mix well.

When the dough has risen, flour your hands and pick up an egg-sized ball of dough. Flatten it into a disk in the hollow of your hand, and place in the center about a tablespoon of the beef mixture. Fold the dough in half over the filling and pinch the edges together. Repeat to make the remaining piroshkis, placing them on a plate lined with parchment paper. Cover with a towel and leave to double in volume. Preheat the oven to 425°F. In a small bowl whisk the egg yolks with a little water or milk. As soon as the piroshkis have risen, brush the top of each with the egg yolk. Bake for 10 to 15 minutes until golden. Piroshkis are excellent piping hot with borscht. They can be reheated, but cover them with a moist cloth in a low oven so they remain soft.

Carrot salad with cumin
Serves 6

1¾ pounds carrots; 3 garlic cloves; salt; freshly ground black pepper; 1½ tablespoons olive oil; juice of 1½ lemons; 2 teaspoons powdered cumin; 6 small white onions; 1 tablespoon chopped flatleaf parsley; 1 tablespoon chopped fresh coriander; 4 plum tomatoes

Peel the carrots and cut into 1½-inch sections. Slice each section lengthwise into halves or quarters, depending on thickness. Place the carrots in a saucepan and just cover with cold water. Crush the garlic cloves in a garlic press and add to the carrots. Season with salt and freshly ground pepper. Bring to a boil, cover, and boil lightly for about 8 minutes, or until carrots are just tender.

Meanwhile, in a salad bowl combine the olive oil, lemon juice, and cumin. Season generously. Drain the cooked carrots, add to the sauce, and toss.

Carrot salad with cumin

Just before serving, finely chop the white onions, the parsley, and the coriander. Make an x-shaped incision in the base of each tomato. Plunge them into boiling water for a few seconds, then immediately place them under cold water. Peel, cut into 6 sections, and seed. Toss the onions, herbs, and tomatoes with the carrots, and serve.

Note: This dish may be prepared the night before. It will taste all the better, with the carrots glazed in the juice. At the last moment add the onions, tomatoes, and fresh parsley and coriander.

Russian olive salad

Serves 6

3 large carrots; 3 potatoes; ¼ teaspoon coarse salt; 3 eggs; 10 ounces fresh garden peas, or 5 ounces shelled peas; 3 peppermint leaves; 2 large tomatoes; 2 sweet pickles; 1 can quality crabmeat, drained; ½ cup small black Niçoise olives

SAUCE: 1 egg yolk; 1 cup peanut oil; juice of ½ lemon; 4 sprigs fresh fennel, chopped; salt; freshly ground black pepper

Peel the carrots and potatoes. Dice into ½-inch cubes. In a stockpot, cover the carrots with cold water, then add the coarse salt. Bring to a boil. Plunge the potato cubes into the pot with the carrots and boil for 5 to 8 minutes until tender. Drain. In a saucepan, cover the eggs in water and boil for 12 minutes. Cool under cold water, then shell and slice thin.

If necessary, shell the peas, then boil for 15 minutes with the peppermint leaves. Rinse under cold water,

then drain. Remove the peppermint leaves. Make an x-shaped incision in the base of each tomato. Plunge them into boiling water for a few seconds, then immediately place them under cold water. Peel and seed the tomatoes. Dice the tomato flesh into small cubes. Slice the pickles lengthwise, then cut into thin disks. In a large bowl, combine the pickles, tomato, potato and carrot cubes, peas, and drained crab.

In a medium bowl, whisk the egg yolk, adding the oil gradually in a thin stream. Add the lemon juice, then sprinkle with the chopped fennel. Season, then pour over the vegetables. Arrange the salad in a pyramid on the serving dish. Surround the salad with the egg slices and black olives. Place a black olive at the top of the pyramid and refrigerate until serving.

Roasted eggplant with marjoram
Serves 6

3 small eggplants; 3 sprigs fresh marjoram; 6 tablespoons olive oil; 2/3 cup small black Niçoise olives; salt; freshly ground black pepper

Remove the marjoram leaves from their stems, then combine stems and leaves with the olive oil. Crush with a pestle in the oil.

Slice off the green stems of the eggplants, then wash the eggplants and wipe dry. Leaving the skin intact, cut lengthwise into 3/8-inch slices. Lightly sprinkle salt on each slice. Place the slices on top of one another in small piles in a bowl.

After 1 hour, press the slices together to remove their bitter juices. Blot dry on paper towels.

Preheat the oven to 425°F. Lightly coat a shallow pan with the marjoram-olive oil. Place the eggplant slices head-to-tail in a single layer. Season with freshly ground pepper. Sprinkle with 2 tablespoons marjoram oil and 1 glass water. Bake for approximately 30 min-

utes until soft. Meanwhile, pit the olives and mince their meat. Remove the eggplants from the oven and place the slices decoratively on a large serving dish. Bake any remaining eggplant slices in the same way. Cool completely before sprinkling on the chopped olives. When serving, season with the remaining marjoram-olive oil.

Note: Sliced ripe tomatoes may be added to the bed of eggplants, then seasoned with salt, pepper, and olive oil. One heaping tablespoon dry oregano may be substituted for the fresh marjoram.

Eggplant caviar
Serves 6

4 medium eggplants; 10 small white onions (or 1 large onion); juice of 1 lemon; 1 tablespoon red wine vinegar; 1 tablespoon extra-virgin olive oil, plus extra for brushing; salt; freshly ground black pepper; 2 tablespoons chopped fresh fennel greens

Preheat the oven to 425°F. Slice off the eggplant stems. Cut the eggplants in half lengthwise. Slice the flesh in narrow criss-crosses without piercing the skin. Lightly brush the half-eggplants with olive oil. Place skin-side up on a baking sheet and bake for 30 minutes.

Meanwhile, peel and finely chop the onions. Remove the eggplant from the oven and scoop out the pulp with a spoon. Chop the pulp with a knife or with a mezzaluna. In a bowl, combine the eggplant with the chopped onions, lemon juice, vinegar, and olive oil. Season with salt and freshly ground pepper. Sprinkle with chopped fennel and stir. Cover the bowl and refrigerate. Enjoy fresh eggplant caviar with blini (see recipe page 146) or toasted country bread.

OPPOSITE: *Roasted eggplant with marjoram.*

White bean salad.

White bean salad

Serves 6

1 pound fresh white beans (about 5½ pounds beans in the pod); 2 carrots; 4 small white onions; 2 garlic cloves; 1 tablespoon olive oil; 1 tied bouquet garni (parsley, thyme, bayleaf, 1 small celery stalk, and two sage leaves); 1 tablespoon coarse salt; freshly ground black pepper

DRESSING: 5 tablespoons extra-virgin olive oil; 2 tablespoons sherry vinegar; a few drops balsamic vinegar; salt; freshly ground black pepper; ½ bunch flatleaf parsley

Shell the beans. Peel and finely chop the carrots and onions. Using the blade of a knife, crush the peeled, whole garlic cloves. Over medium heat, heat the olive oil in a stockpot. Add the carrots, onions, garlic cloves, and bouquet garni, and sauté for 5 minutes, stirring constantly. Add the white beans and 8 cups water. Over low heat, bring just to the boiling point. Half-cover the pot and simmer for approximately 30 minutes. Ten minutes before the end of cooking, add the salt. (Do not salt at the beginning as this would harden the beans' skins.) Check to see if the beans are fully done before draining and drying on paper towels. Remove the bouquet garni and the garlic cloves.

Finely chop the parsley. Combine the dressing ingredients, except for the parsley, in the bottom of a large salad bowl. Toss in the still-hot beans and finely chopped parsley. This salad is best served warm.

Note: This salad may also be made with dried beans. To do so, cover the beans with water in a stockpot and bring to a boil. Remove from the heat and allow to soak for 1 hour. Drain. Follow the above recipe, but simmer for about 90 minutes until tender.

Anchovy terrine with parsley vinaigrette

Serves 6

30 whole, salted anchovies; 6 eggs; 3 large shallots; ½ bunch flatleaf parsley; 6 tablespoons extra-virgin olive oil

Rinse the anchovies one by one under cold water, pressing out the salt with your fingers. With the tip of a moist cloth, carefully wipe the anchovies to remove their fine scales. Place the anchovies in a large bowl and cover with fresh water. Allow to soak for at least two hours, changing the water from time to time. Drain, then carefully pat the anchovies dry with paper towels. Split the anchovies in two lengthwise and delicately remove the bones.

In a saucepan, cover the eggs in water and boil for 12 minutes. Cool under cold water, then shell and slice the eggs.

Peel and finely chop the shallots. Chop the parsley leaves. Place a first layer of the anchovy fillets in the

bottom of a terrine (an earthenware pot for making pâté), then top with a layer of egg slices. Sprinkle with parsley and shallots and drizzle with olive oil. Continue in the same way until all ingredients have been used, ending with egg slices on top. Sprinkle again with parsley, shallots, and olive oil.

Serve cold with garlic-rubbed toast, fresh tomatoes, lemon quarters, capers, or quartered lettuce hearts.

Note: This starter may also be made with boned anchovy fillets in oil. To do this, finely chop the eggs and omit the olive oil except a drizzle on the very top layer.

Oriental marinated cucumbers
Serves 6

1 tablespoon coriander seeds; 12 mixed peppercorns; 1 tablespoon extra-virgin olive oil; 1 tied bouquet garni (1 celery stalk, the green stalks of 2 fennel bulbs, 2 bayleaves, 3 sprigs thyme, and parsley); juice of 1 lemon; salt; 2 English cucumbers

With a mortar and pestle, coarsely grind the coriander seeds and peppercorns. In a stockpot, combine the coriander seeds, peppercorns, olive oil, bouquet garni, lemon juice, and salt. Add 4 cups water and bring to a boil. Meanwhile, peel the cucumbers and halve lengthwise. Use a spoon to scrape out any seeds, then slice each half into 3/8-inch slices or sticks, according to preference.

Add the cucumber to the boiling stock. Return to a fast boil and boil for a few minutes. Cooking time depends on the size of the cucumber pieces. They should be a bit crispy.

Remove the cucumbers from the stock and place in a large bowl. Simmer the stock until it has reduced to 1 cup. Remove from the heat, remove the bouquet garni, and cool completely before pouring over the cucumbers.

Refrigerate the salad for 24 hours. Serve cold. Chopped peppermint, coriander, or parsley may be added before serving, according to taste.

Note: Substitute other vegetables (cauliflower florets, broccoli or cabbage, baby artichoke quarters, fresh stringbeans) for a refreshing appetizer.

Soft-boiled eggs with spinach
Serves 6

4 pounds fresh spinach; 6 extra-fresh eggs; 4 tablespoons butter; 6 slices white country bread, crusts removed; coarse salt; freshly ground black pepper; 1 cup heavy cream

Stem and wash the spinach. Drain. Bring a large volume of water to a boil in a stockpot and add the spinach. Return to a boil and boil for 3 minutes. Drain, pressing out all the cooking water.

In a saucepan, just cover the eggs in water. Bring to a boil and boil for 3 minutes. Drain the eggs and set aside.

In a small saucepan, slowly melt 2 tablespoons of the butter. When solids form, pour the clear butter off the solids and discard the solids. Heat the clarified butter in a frying pan and brown the bread on both sides in the butter.

Melt the remaining butter in a high-sided frying pan. Add the spinach and coat with the butter. Season with salt and freshly ground pepper. Remove the spinach from the frying pan and keep hot. Pour the cream into the same frying pan and allow to reduce by half

over medium heat. Season with salt and freshly ground pepper.

Place the fried croutons on a serving dish or individual dishes. Split each soft-boiled egg in half with a knife and use a spoon to scoop the egg from the shell. Place one egg in the center of each crouton. Coat with the cream. Arrange the spinach in a circle around each egg. Serve immediately.

Soft-boiled eggs with spinach.

Pissaladière (onion tart)

Serves 6

6 1/2 pounds onions; 1 tablespoon olive oil; 1 heaping tablespoon dry oregano; 1 tied bouquet garni (parsley, bayleaf, and thyme); 2 garlic cloves; salt; 1 pound basic bread dough (this can sometimes be ordered from a bakery); 12 anchovy fillets in oil; 20 small, black Niçoise olives; freshly ground black pepper

Peel and finely chop the onions. In a stockpot, heat the oil over low heat. Add the onions and oregano, coating them in the oil. Add the bouquet garni and the peeled, whole garlic cloves. Lightly season with salt. Cover the pot and allow to stew over very low heat for at least 1 1/2 hours. The onions must become transparent, but must not brown. Check often, stirring from time to time.

Using your hands, shape the bread dough into a disk approximately 1/4 inch thick. Place into a moistened tart pan, making an edge approximately 1 inch in height all around. Cover the dough with a cloth and let rise, away from drafts, until it has doubled in volume. Preheat the oven to 400°F. Bake the risen crust for 10 minutes to dry it. Remove from oven, but do not turn off the heat.

Remove the bouquet garni and garlic cloves from the onion purée. Using a slotted spoon or skimmer, remove the onions from the stockpot and distribute them over the dough. Smooth the top with the back of a spoon. Arrange the anchovy fillets in a star shape on the onions. Bake for 15 minutes. Remove the tart from the oven. Decorate with Niçoise olives, and season with freshly ground pepper. Onion tarts are best eaten piping hot from the oven, but can also be enjoyed warm.

Zucchini fritters

Serves 6

30 zucchini flowers; salt

**BATTER: 1 tablespoon butter; 4 egg yolks; 1 generous cup
flour; ½ cup milk; salt; 1 egg white; vegetable oil for frying**

Melt the butter over low heat in a saucepan, then remove from heat. Whisk the egg yolks in a small bowl. Sift the flour into a large bowl, make a well in the center, and add the milk, egg yolks, and melted butter, then a few pinches of salt. Whisk the milk with the eggs and butter, drawing in the flour from the edges. Cover with a kitchen towel and set aside for 1 hour.

Separate the small zucchini from their flowers and reserve the zucchini for another use. Wash the zucchini flowers under cold running water. Dry them on all sides with paper towels. Remove the large yellow pistil from the center of each flower.

Just before frying the fritters, beat the egg white into stiff peaks, adding a pinch of salt. Fold the white delicately into the dough. Drop in 2 or 3 ice cubes. Heat 3 inches oil in a pan for deep frying. To test if the oil is hot enough, drop a bit of the fritter dough into the oil. If the oil temperature is correct, the dough should crackle. Dip zucchini flowers in the batter, then plunge them into the hot oil. Brown for a few minutes on each side, then remove to drain on paper towels. Repeat with the remaining flowers. Sprinkle with salt and serve hot.

OPPOSITE: *Zucchini fritters.*

Fish

Sardines stuffed with Chinese cabbage

Serves 6

1 bunch Chinese cabbage (Napa cabbage); 2 garlic cloves; olive oil; salt; 20 large, fresh sardines; 2 eggs; freshly ground black pepper; 7 tablespoons seasoned breadcrumbs

Detach the green leaves from the white ribs of the Chinese cabbage, and reserve the ribs for another recipe. Wash and drain the green leaves. Pile them up, roll them together into a cylinder, and finely slice them with a knife.

Peel the garlic cloves, cut them in half, and remove the green germ. Heat 1 teaspoon olive oil in a high-sided frying pan. Toss the garlic cloves into the hot oil and fry for 1 minute. Add the chopped green leaves and season with salt. Cover the frying pan and simmer until all the water disappears, stirring from time to time during cooking.

Meanwhile, remove the heads of the sardines and "butterfly" the bodies by slicing them almost in half from the stomach to the back without cutting through the backbone or the tail. Empty the stomach cavity. Wash under cold running water and pat dry. Remove the bones. Place flat, flesh-side up, on the work surface.

Remove the garlic cloves from the cabbage leaves and let cool. Whisk the eggs in a large bowl, then add the cabbage leaves. Season with salt and freshly ground pepper, and mix. Place a heaping spoonful of cabbage leaves in the center of each sardine.

Preheat the broiler. Lightly coat a broiler pan with olive oil. Place the stuffed sardines perfectly flat on the pan. Sprinkle each sardine with about 1 teaspoon breadcrumbs and drizzle lightly with olive oil. Place the broiler pan 6 inches from the heat source in the oven and grill for approximately 5 minutes. Serve hot.

Salmon koulibiac

Serves 6 to 8

DOUGH: 2²/₃ cups flour; 2 eggs; 1 cup (2 sticks) butter, softened; 1 teaspoon salt; 1 egg yolk

FILLING: 3 eggs; 1 salmon fillet (approximately 1 pound, skin removed); 1¹/₂ tablespoons dry white wine; salt; 1 tied bouquet garni (parsley, bayleaf, and thyme); 3 shallots; 12 ounces crimini mushrooms; 1 tablespoon butter; freshly ground black pepper; ³/₄ cup long-grain rice; 2 sprigs fennel, finely chopped

SAUCE: 8 tablespoons butter; 3 sprigs fennel, finely chopped

To make the dough, sift the flour into a large bowl. Make a well in the center and add the eggs and the soft butter, cut into lumps. Dissolve the salt in 5 tablespoons water. Quickly work the flour into the eggs and butter, adding the salted water little by little. Gather the dough into a ball, wrap in plastic wrap, and refrigerate for 2 hours.

In a small saucepan, cover the eggs in water and boil for 12 minutes. Cool under cold water, then shell. Cut the eggs in half and mash roughly with a fork.

Using tweezers, carefully remove the bones from the salmon fillet. Pour the white wine and 3 glasses water into a saucepan. Season with salt and add the

OPPOSITE: *Sardines stuffed with Chinese cabbage.*

bouquet garni. Bring to a boil, then plunge in the salmon. Return to a boil, and boil for 5 minutes. Remove from the heat and let the salmon cool in the cooking liquid. Drain the salmon and break it into small pieces.

Peel and finely chop the shallots. Trim the stems off the mushrooms. Clean the mushrooms thoroughly under running water. Cut into small pieces. Melt the butter in a high-sided frying pan, then add the shallots, stirring constantly. When the shallots become transparent, add the mushrooms. Cook over low heat for 5 minutes, stirring. Season with salt and freshly ground pepper. Cook the rice in salted boiling water until tender. Drain and cool. Season with finely chopped fennel.

Preheat the oven to 400°F. On a floured work surface, pat the dough into a rectangular shape ¼-inch thick. Slice off the edges to form a clean rectangle. On one-third of the dough, with a border of 1½ inches on the edges, spread half the rice, then the salmon, mushrooms, eggs, and finally the remaining rice. Moisten the edges of the dough with water. Raise the free end of the dough, then fold it over the filling and pinch the edges together. The dough leftovers can be used to decorate the koulibiac. Beat the egg yolk with 1 teaspoon water and dab the dough with this mixture. Bake for approximately 30 minutes, until golden.

To make the sauce, melt the butter gently in a saucepan. Pour into a sauceboat and sprinkle with the chopped fennel. Serve with the hot koulibiac.

Mullet à la niçoise.

Mullet *à la niçoise*
Serves 6

12 mullets (approximately 4 ounces each); salt; freshly ground black pepper; 2 tablespoons flour; 2 tablespoons extra-virgin olive oil; generous 2 pounds tomatoes; 5 tarragon leaves; 3 lemons; 12 anchovy fillets in oil; 2 tablespoons capers; ½ cup black Niçoise olives; 2 tablespoons seasoned breadcrumbs; 3 tablespoons butter

Ask your fishmonger to scale and clean the mullets, keeping their livers inside. Salt and pepper the fish. Put the flour on a plate. Roll the mullets in the flour, then delicately shake off any excess.

Heat 1 tablespoon oil in a large frying pan. Brown the mullets for 1 minute on each side.

Make an x-shaped incision in the base of each tomato. Plunge them into boiling water for a few seconds, then immediately place them under cold water.

Peel, halve, and seed. Crush the pulp and place in a bowl. Chop the tarragon leaves and stir into the tomato pulp. Season with salt and freshly ground pepper. Drain in a strainer.

Preheat the oven to 300°F. Distribute half the tomatoes in the bottom of a large gratin dish. Place the mullets in the dish. Peel 2 of the lemons and cut into thin round slices. Slip one slice between each of the mullets. Cover with the rest of the tomatoes. Cut the anchovy fillets into fine strips and distribute on top of the tomatoes. Top with capers and olives. Sprinkle with the juice of one-third lemon. Sprinkle the surface with a fine layer of breadcrumbs, then drizzle with the remaining olive oil.

Bake for 20 minutes and remove from oven. Melt the butter over medium heat. As soon as it starts to brown, pour it over the mullets. Serve immediately.

Bouillabaisse
Serves 6 to 8

BROTH: 2 onions; 2 leeks, white part only; 4 garlic cloves; 1/2 cup olive oil; 1 sprig thyme; 1 bayleaf; 3 sprigs fennel; generous 2 pounds mixed rock fish such as eel, small crabs, yellowtail, or gurnards, cleaned but neither scaled nor dressed, cut into large pieces; 5 1/2 pounds whole fish such as porgy, monkfish, cod, red snapper, or flounder, filleted and cut into sections, keeping heads and tails for the soup; coarse salt; freshly ground black pepper; a dash cayenne; 3 tomatoes; 2 doses powdered saffron; 2 pieces dried orange rind; 2 table-spoons tomato paste

ROUILLE (SPICY SAUCE): 2 to 3 small hot peppers, seeded; 2 garlic cloves, peeled; 2 packets powdered saffron; 1 potato, boiled; 1 cup olive oil

Begin by preparing the broth. Peel, then finely chop the onions and the leeks. Peel and crush the garlic cloves. Heat the olive oil with the garlic in a stockpot. Stir in the onions, leeks, thyme, bayleaf, and fennel.

Reduce the heat and gently stew without browning, stirring often. When the onions are translucent, add the rock fish as well as the heads and tails of the filleted fish. Season with coarse salt, freshly ground pepper and cayenne. Raise the heat, cover, and cook for 10 minutes. Cut the tomatoes into pieces and add them to the pot with the saffron, orange rind, and tomato paste. Add water to cover. Stir, then bring to a boil over high heat. Cover the pot and boil for 20 minutes. Purée the soup with all its ingredients in a food processor, then strain in a chinois (small conical strainer). Pour the liquid back into the stockpot and discard the solids. Over high heat, plunge the filleted fish one by one into the broth, largest pieces first. Bring to a boil, cover, and boil for 8 to 10 minutes.

Meanwhile, make the rouille. With a mortar and pestle, mash the hot peppers, the 2 garlic cloves, the saffron, the potato, and 1 tablespoon broth. Pour in the olive oil in a thin stream, blending constantly.

Using a skimmer, remove the fish sections and place on a deep service dish. Pour the broth into a tureen. Serve over croutons fried in olive oil, with Parmesan cheese and the rouille drizzled on top.

Brandade de morue
Serves 6

1 2/3 pounds salt cod (skin on); 1 garlic clove; about 1 1/2 cups milk; about 1 1/2 cups virgin olive oil (first press); juice and grated zest of 1/2 lemon; freshly grated nutmeg; freshly ground white pepper; 10 bread croutons, fried in oil

Immerse the cod in a large bowl of cold water. Allow to soak and soften for 24 hours, changing the water several times.

Cut the cod into pieces and place in a saucepan. Cover well with cold water, then bring to a simmer over low heat. Do not let it boil. The simmering-point is indicated by the formation of an increasingly thick,

white foam. Remove the foam with a skimmer and remove the pan from the heat. Cover the pan for 1 minute to poach. Remove the pieces of cod and drain them on paper towels. Carefully remove all the bones and any scales, but keep the skin as it helps make a richer, more savory brandade. Trim the pieces of cod and place in a mortar with the garlic clove. Using a pestle, crush the cod into a purée.

Pour the milk into a small saucepan, and the oil into another. Place them over very low heat, just to warm. Pour a tablespoon of the oil into a thick-bottomed pan. Place over very low heat, then add the cod. Vigorously work the purée, blending in a little warm oil, then a little warm milk. Mash the mixture thoroughly against the sides of the pan, adding more milk and more oil. The brandade is almost ready when creamy. Add the lemon juice and zest to the brandade. Season with a little grated nutmeg and freshly ground white pepper. Taste, then add a little salt if necessary. Serve the brandade hot with the croutons. It also complements baked potatoes particularly well.

Note: A good brandade requires strong arms! It is best to work in relay, but you can also use an electric mixer, providing you keep the cod, milk, and oil hot.

Grilled bass with fennel
Serves 6

1 large bunch dry, wild fennel twigs; 1 tablespoon extra-virgin olive oil; 1 teaspoon dried oregano; 1 teaspoon ground fennel; a dash cayenne; salt; freshly ground black pepper; 2 sea bass (at least 2 pounds each, cleaned but not scaled)

Begin by preparing the grill. Make a wood fire to the point of glowing hot coals.

In a large bowl, combine the olive oil, oregano, fennel, cayenne, salt, and pepper. Season the bellies of

the bass with salt and pepper. Top the fish with fennel twigs. Make 2 or 3 incisions in the flanks of the bass. Brush the fish with the oil mixture on all sides, then place in a folding, double-sided grill.

Add some dried fennel sprigs to the embers and grill the bass over them, about 5 or 6 inches from the heat. Turn the grill often, each time brushing the bass with the oil. From time to time, add dried fennel sprigs to the embers. Cooking time varies from 15 to 20 minutes. To see if the bass are done, insert a skewer or the tip of a knife into their flanks. If the juice that flows out is still pink, continue cooking.

When the bass are done, pull off the skins and serve, accompanied by extra-virgin olive oil for drizzling.

OPPOSITE: *Grilled bass with fennel.*

Sea bream with candied lemons

Serves 6

1 large onion; 2 candied lemons, or 3 ounces candied lemon rind in strips; 1 tablespoon coriander seeds; 1 inch fresh ginger (or ½ teaspoon powdered ginger); ½ cup dry white wine; 2 sea breams, a generous 2 pounds each, cleaned and scaled but whole; coarse salt; freshly ground black pepper; ½ cup olive oil; ½ cup pitted green olives

Oil the bottom of a baking dish large enough to hold the two sea breams side by side.

Peel and thinly slice the onion. Cut the candied lemons in half, then remove and discard the pulp. Slice the rind into fine strips. Mix half the candied lemon rind with the onions. Distribute over the bottom of the baking dish.

Preheat the oven to 475°F. Using a pestle, crush the coriander seeds in a large bowl. Peel and julienne the ginger. Mash the ground coriander seeds with the ginger, using the pestle. Distribute half over the onions. Sprinkle in the white wine. Place the dish in the oven and bake for 10 minutes, stirring occasionally with a wooden spoon.

Wash the sea breams and wipe them dry. Cut 3 small incisions into each flank. Mix the remaining candied lemon rind with the remaining coriander and ginger. Slip a lemon rind strip into each incision. Place the rest of the lemon mixture inside the fish, then sprinkle them with coarse salt and freshly ground pepper.

Remove the dish from the oven and place the fish on the onion bed. Drizzle with the olive oil. Bake for 30 minutes in the oven, basting the fish often with the juices in the dish. Five minutes before the end of cooking, top with the olives. Serve hot.

Mussels in sauce poulette

Serves 6

4 pounds mussels; 2 shallots; 2 tablespoons butter; generous 1 cup dry white wine

SAUCE POULETTE: 3 egg yolks; juice of ½ lemon; 2 tablespoons butter; a dash salt; freshly ground black pepper; ½ bunch flatleaf parsley, leaves only, finely chopped

In a large bowl, rinse the mussels, discarding any broken ones, and drain. Peel and finely chop the shallots. Slowly melt the butter in a deep, wide stockpot. Add the shallots and stir for a few minutes over low heat. The shallots should become transparent. Add the wine. Bring to a boil, then add the mussels. Cover the pot and cook the mussels over high heat for 4 to 5 minutes, shaking the pot vigorously several times.

Line a strainer with cheesecloth and strain the mussel liquid into a saucepan. Cool. Remove and discard any unopened mussels, then cover the stockpot to keep the mussels hot.

Vigorously beat the egg yolks into the cooled mussel liquid. Over low heat, stir the liquid until it simmers. Immediately remove from the heat and whisk in the lemon juice. Put the pan back on the heat and add the butter, whisking constantly. Taste, and adjust the seasoning with salt and freshly ground pepper. Pour the mussels into a serving dish and pour the hot sauce over the mussels. Sprinkle with finely chopped parsley and serve hot.

Spicy Mediterranean prawns
Serves 6

2 dozen Mediterranean prawns (langoustines); 4 tablespoons olive oil; salt; freshly ground black pepper; 1 or 2 small hot peppers, seeded; 1 tomato; 6 garlic cloves; a dash cayenne; 2/3 cup dry white wine; 1 unwaxed lemon

Remove the heads and shells from the prawns, and set the shells and heads, and the bodies aside separately. In a large frying pan, heat 1 tablespoon olive oil over high heat. Sauté the prawns for 1 minute on each side, then drain on paper towels. Season with salt and freshly ground pepper.

Chop the hot peppers into small pieces. Roughly cut the tomato and chop 2 of the garlic cloves. Replace the frying pan over high heat and add 1 tablespoon olive oil. Add the shells and heads, and the hot peppers. Brown, stirring, for approximately 5 minutes before adding the tomato and the 2 chopped garlic cloves. Season with salt and cayenne. Simmer for 5 minutes, then add the white wine and 1 glass cold water. Wash the lemon. With a paring knife, peel the entire rind and add it to the pan. Bring to a boil, then reduce heat, cover, and simmer approximately 20 minutes. The liquid should be reduced by half. Set aside to cool.

Press the remaining garlic cloves. In a large serving dish, combine the lemon juice, the remaining olive oil, and the pressed garlic. Add the prawn bodies and coat with the juice. Arrange them attractively in the dish, cover, and macerate 1 hour in the refrigerator.

Pour the shells and stock through a fine sieve or chinois, reserving the liquid in a large bowl. Cool. Remove the lemon zest from the shells and finely chop the zest. Pour the cooled liquid over the macerated prawns. Sprinkle with the chopped lemon zest. Cover and refrigerate for 24 hours. Serve cold, accompanied with garlic bread.

Poultry, Meat

Pastilla with almonds and pigeon

Serves 6

3 onions; 3 pigeons, with bones, cut into small pieces; 1 inch fresh ginger, peeled and grated (or ½ teaspoon powdered ginger); 1 packet powdered saffron; salt; 6 tablespoons butter; 1 bunch fresh coriander; ½ bunch flatleaf parsley; ½ cup confectioners' sugar, plus extra for decoration; 1 teaspoon cinnamon, plus extra for decoration; 6 eggs; ¾ cup chopped blanched almonds; 12 leaves filo dough; 2 egg yolks

Peel the onions and grate them using the large holes of a grater. In a stockpot, combine the pigeon, 2 cups water, the ginger, saffron, a pinch salt, 4 tablespoons of the butter, and the grated onions. Bring to a boil over low heat. Half-cover the pot and reduce the heat. Simmer for 40 minutes.

Finely chop the coriander and parsley leaves. Using a skimmer, remove the pieces of pigeon from the pot and set aside. Over low heat, add to the pot the sugar, cinnamon, coriander, and parsley. Stir well and simmer until the liquid is reduced by half.

Beat the eggs in a large bowl. Add 1 cup of the cooking liquid to the eggs, whisking constantly. Pour the egg mixture into the pot and stir constantly with a wooden spoon for 5 minutes. Remove from the heat and set aside to cool completely.

Bone the pieces of pigeon, and trim the meat to uniform size.

Preheat the oven to 400°F. In a frying pan, dry-fry the chopped almonds.

Generously butter two 8 x 3-inch round cake pans.

Overlap 6 filo leaves on the bottom of one pan and up the sides. They should extend well out of the pan. Distribute the pigeon over the filo, then pour in the liquid and sprinkle with the chopped almonds. Place 2 filo leaves on top of the stuffing. Fold the edges of the first filo leaves over the 2 leaves on top. Flatten well and brush with the egg yolks. Line the second pan with 3 filo leaves, again making them overlap and stick out of the pan. Press these leaves so they adhere to one another. Carefully invert the pastilla into the second pan. Fold the extending filo over the top of the pastilla and again brush with egg yolk. Place the last filo leaf on top, tucking its edges down the sides.

Slice the remaining butter and slip some slices between the pan and the pastilla all around the edge. Bake for 35 to 40 minutes. Every 10 minutes, slip more lumps of butter between the pan and the pastilla.

Remove from the oven, place a serving dish over the pan, and turn the pastilla onto the dish. Top generously with sifted confectioners' sugar, and decorate with fine lines of powdered cinnamon. Serve hot.

Leg of lamb pot-pourri

Serves 6

8 garlic cloves; 1 boned leg of lamb (a generous 3 pounds); 5 sprigs marjoram; 10 sprigs thyme; coarse salt; freshly ground black pepper; 4 tablespoons olive oil; 6 carrots; 4 onions; 6 turnips; 2 cups dry white wine; 1 tied bouquet garni (parsley, bayleaf, fennel); 3 small eggplants; 2 green bell peppers; 8 tomatoes; 15 basil leaves, finely chopped

Peel the 6 garlic cloves. Place the leg of lamb flat on the work surface. Place the garlic cloves in a line across the center of the meat. Crumble the marjoram and thyme over the leg of lamb. Roll up the lamb and tie it in 4 places. Season with coarse salt and freshly ground pepper. Heat 3 tablespoons of the olive oil in a stockpot. Brown the leg of lamb on all sides.

Peel and chop the carrots, onions, and turnips. Toss them into the pot, stirring them in the oil. Cook for a few minutes to lightly brown the onions. Add the white wine and 2 cups water. Crush the remaining un-peeled, whole garlic cloves with the blade of a knife, and add them to the vegetables with the bouquet garni. Bring to a boil, then reduce the heat, cover, and simmer for 2 hours.

Meanwhile, dice the eggplants into large cubes. Cut the bell peppers in half and remove the seeds. Cut the peppers into strips. Quarter the tomatoes. Heat the re-maining olive oil in a large frying pan and add the egg-plants and bell peppers. Stir until they start to brown. Add the tomatoes and season with salt and freshly ground pepper. Stir well and cook over high heat for another 5 minutes. When the stew has simmered for 2 hours, pour the vegetable fricassee into the stockpot. Stir, and turn the leg of lamb over. Sim-mer for 1 hour.

Remove the bouquet garni and the garlic. Adjust the seasoning if necessary. Place the leg of lamb on a serving dish and remove the string. Surround the lamb with the vegetable pot-pourri. Sprinkle the vegetables with finely chopped basil leaves.

Kiev cutlets

Serves 6

2 sticks butter; salt; freshly ground black pepper; 5 sprigs fresh fennel; 6 chicken breasts; 2 tablespoons olive oil; 2 tablespoons flour; 2 eggs; 2 tablespoons milk; 1 cup bread-crumbs; 2 cups vegetable oil, for frying

SALAD ACCOMPANIMENT: 3 carrots; 1 small daikon; 2 red beets; 6 tablespoons olive oil; 2 tablespoons sherry vinegar

Break the butter into pieces and bring to room temper-ature in a large bowl. Season with salt and freshly ground pepper. Finely chop the fennel sprigs and cut them into the butter. Divide the butter into 6 parts, shaping them into small sausage shapes. Wrap each separately in plastic wrap and freeze for 2 hours.

Slice through each chicken breast with the blade of the knife parallel to the work surface, stopping $1/2$-inch short of the edge. Open each cutlet. Place a ball of the frozen butter and fennel on the edge of each cutlet, then roll it up. Close each end with a wooden tooth-pick. Brush the cutlets with oil and season with salt and freshly ground pepper. Lightly sift the 2 table-spoons flour onto the cutlets. Whisk the eggs and the milk together in a bowl. Measure the breadcrumbs onto a plate. Dip the cutlets in the eggs, then roll gen-erously in the breadcrumbs.

To make the salad, peel the carrots, daikon, and beets. Grate them using the large holes of a grater. Combine the vegetables in a large bowl with the olive oil and vinegar. Season with salt and freshly ground pepper and refrigerate.

Heat the vegetable oil in a large frying pan. Fry the cutlets for 4 to 5 minutes on each side until browned. Drain on paper towels and serve hot with lemon quar-ters and the salad.

Provençal stew

Serves 6

5 ounces lard; 5 sprigs thyme; ¹/₂ teaspoon coarse salt, plus additional; ¹/₂ teaspoon freshly ground black pepper; 4¹/₂ pounds beef chuck or shank, cut into 2¹/₂-inch cubes; 3 carrots; 3 shallots; 1 garlic clove; 18 large black olives; 1 tied bouquet garni (parsley, bayleaf, and thyme); 1 cup white wine, preferably Côte-du-Rhône; 3 cups red wine, preferably Côte-du-Rhône; ¹/₂ cup dry sherry; 1 teaspoon wine vinegar; 1 tablespoon olive oil; juice and zest of 1 orange; 12 black peppercorns; 1 calf's foot; 7 ounces smoked lard; 3 onions; 3 cloves; 7 ounces bacon, preferably the rind, sliced; 1 cup beef stock; 2 cups flour

Slice the plain lard into as many strips as you have beef cubes.

Crumble the thyme onto a plate and add the salt and pepper. Dredge the strips of lard in this mixture. Make a slit into the center of each beef cube and place a seasoned strip inside. Place the larded beef in a large bowl.

Peel and chop the carrots, shallots, and garlic cloves. Pit the olives. Add to the beef the carrots, shallots, garlic, olives, bouquet garni, white wine, red wine, sherry, vinegar, oil, half the orange zest, and the orange juice. Season with coarse salt, and add the peppercorns. Refrigerate for 12 hours.

Wash the calf's foot and split it in two lengthwise. Place in a saucepan, cover with water, bring to a boil, and boil for 15 minutes. Drain, then bone. Cut the flesh into small cubes and set aside.

Slice the dark-brown outer layer off the smoked lard on all sides. Remove the rind, if any. Dice the remaining lard.

Remove the pieces of beef from the bowl, reserving the marinade. Dry the beef with paper towels.

In a large, heavy-bottomed frying pan, gently brown the diced lard with a few drops of oil. Remove the lard when golden, then increase the heat to high and add the beef cubes. Brown well.

Preheat the oven to 300°F. Peel the onions, pierce each with a clove, and quarter the onions. Line the inside of a large, crockery casserole dish with the bacon rind. In the following order, add the marinade with the vegetables, the onions, the pieces of beef, the diced lard, and the calf-foot cubes. Moisten with the stock.

In a large bowl, knead the flour with enough water to make a dough with the consistency of modeling clay. Line the top edge of the casserole with dough and place the lid on top so the dough seals the lid to the casserole. Place in the oven and bake for 3 hours.

Remove the casserole from the oven and break the dough crust. Using a skimmer, remove the pieces of meat and vegetables to a serving bowl and keep them hot. Place the casserole on the stovetop over medium heat and bring the sauce to a boil. Skim off the foam that forms. Pour the hot sauce over the meat and vegetables and serve.

Note: A generous ladleful of the beef with its juice can be set aside to make authentic Niçois ravioli (see recipe page 175).

Vegetables, Pasta

Eggplant au gratin with tomatoes

Serves 6

3 large eggplants; coarse salt; 3 cups milk; 5 tablespoons olive oil; 2 garlic cloves; 1³/₄ pounds tomatoes; 1 clove; 1 tablespoon dried thyme sprigs; freshly ground black pepper; 2 tablespoons chopped flatleaf parsley; ³/₄ cup freshly grated Parmesan cheese; ¹/₂ cup breadcrumbs

Wash and dry the eggplants. Cut into round slices and layer in a large bowl, sprinkling each layer with coarse salt. Set aside to sweat for about 20 minutes. Rinse the eggplants under water, then replace in the bowl. Cover with the milk and soak for about 20 minutes. Drain. Rinse under water and dry with paper towels.

Heat 2 tablespoons oil in a frying pan and sauté the eggplants for a few minutes.

Crush the garlic cloves using a garlic press. Make an x-shaped incision into the base of each tomato. Plunge them into boiling water for a few seconds, then immediately place them under cold water. Peel, quarter, and seed.

With a mortar and pestle, crush the clove with the thyme. Add the tomatoes, clove, and crushed garlic to the frying pan with the eggplants. Stir. Season with a little salt and pepper. Half-cover the frying pan and simmer for 30 minutes, stirring occasionally.

Preheat the broiler. Combine the parsley with the eggplant mixture. Place the mixture in a gratin dish rubbed with garlic. Top with the freshly grated Parmesan cheese and the breadcrumbs. Drizzle with the remaining olive oil. Broil about 6 inches from the heat source until the cheese and breadcrumbs are golden.

Serve hot or cold-this is the ideal summertime accompaniment for grilled meats and poultry.

Creamed zucchini

Serves 6

6 medium zucchini; 3 fresh sage leaves; salt; freshly ground black pepper; 3 eggs; generous 1 cup crème fraîche; freshly grated nutmeg; 1 garlic clove; ¹/₂ cup seasoned breadcrumbs; 2 tablespoons butter

Trim both ends of the zucchini. Peel the zucchini, leaving alternately a strip of skin, then a strip of pulp. Cut them into ¹/₄-inch slices. Steam the zucchini for 4 to 5 minutes. Drain in a strainer, and mash roughly with a fork. Stir the mashed zucchini in a frying pan over high heat to dry it. Immediately remove the frying pan from the heat. Finely chop the sage leaves and stir them into the zucchini. Season with salt and freshly ground pepper.

Preheat the broiler. Beat the eggs in a large bowl with the crème fraîche. Blend in the zucchini and mix thoroughly. Grate in a little nutmeg, then taste and adjust the seasoning. Peel the garlic and rub it all over the surface and edges of a gratin dish. Butter the dish and pour in the zucchini. Top with the breadcrumbs and sprinkle with small bits of butter. Place in the oven about 6 inches from the heat source and broil until golden. Serve warm or hot.

Stuffed onions, tomatoes, and zucchini

Serves 6

8 tomatoes, ripe but firm; 8 zucchini, round or oblong; 8 medium onions

STUFFING: 4 tablespoons extra-virgin olive oil; 3 garlic cloves; salt; freshly ground black pepper; 5 sprigs thyme; leftover white meat or poultry (approximately 1¾ pounds), with its juice; 2 slices white ham; 1 bunch flatleaf parsley; 4 slices stale country bread, crustless, soaked in a little milk; 1 egg plus 2 yolks; 1 cup seasoned breadcrumbs

Cut the tops off the tomatoes, zucchini, and onions and reserve. If using oblong zucchini, slice off the top one-third, lengthwise. Peel the onions and boil for 20 minutes in salted water. Empty the tomatoes and zucchini of their seeds with a small spoon. Set the pulp aside separately. Salt the inside of the tomatoes, then place in a strainer to release their juice. Blanch the zucchini in salted boiling water for 3 minutes.

Drain the onions and zucchini. Carefully hollow out the onions, leaving only two layers of flesh. Set the pulp aside. Press the pulp of the zucchini to eliminate as much water as possible. Chop the pulp of the blanched onions with that of the zucchini. Heat 1 tablespoon olive oil in a frying pan. Brown the zucchini and onion pulp. Peel and finely chop the garlic, and add to the pan. Simmer for 5 minutes. Season with salt and freshly ground pepper, then add the crumbled thyme.

Cut the white meat into pieces. Remove the rind from the ham and cut it into small pieces. In a large bowl, mash the meat and ham together until a rather coarse mixture forms. Finely chop the parsley leaves. Add to the meat the zucchini mixture, parsley, the soaked white bread, the egg and egg yolks, and the meat drippings (or substitute some crème fraîche). Taste the stuffing and adjust the seasoning. Mix thoroughly until the stuffing is soft and spongy.

Preheat the oven to 350°F. Generously oil a large gratin dish. Stuff the inside of the onions, tomatoes, and zucchini with the filling. Place the vegetables side by side, close together in the gratin dish. Sprinkle with breadcrumbs, then drizzle with 2 tablespoons oil. Cover them with their tops.

Over high heat, heat 1 tablespoon olive oil and brown the tomato pulp and seeds. Run this pulp through a vegetable mill or food processor on a fine setting. Add the juice to the gratin dish. Bake in the oven for 1 hour, basting the vegetables frequently. Serve hot or cold.

Artichoke ragoût

Serves 6

15 baby artichokes; juice of 1 lemon; 2 carrots; 4 white onions; 2 celery stalks; 4 garlic cloves; 4 tablespoons olive oil; 5 ounces smoked bacon, diced; 1 tied bouquet garni (parsley, bayleaf, and thyme); ⅔ cup dry white wine; coarse salt; freshly ground black pepper; ½ cup black Niçoise olives; 2 tablespoons finely chopped flatleaf parsley

Remove the bottom leaves from the artichokes. Trim the stems, keeping 1½ inches. Fill a large bowl with cold water and add the lemon juice. Cut the artichokes in half and place in the bowl.

Peel and dice the carrots, onions, and celery. Peel and crush the garlic cloves.

Heat the oil in a large high-sided frying pan and add the diced bacon. Brown, stirring constantly. Add the diced carrots, onions, and celery. Stir over medium heat until the onions become transparent. Drain the artichokes, then add to the frying pan with the bouquet garni and the garlic cloves. Coat well with the oil. Add the wine and a glass of water. Season with salt and freshly ground pepper. Bring to a boil, then reduce the heat, cover, and simmer for approximately 30 minutes. Remove the bouquet garni, then add the olives. Pour into a large, deep serving dish and sprinkle with parsley.

Artichoke ragoût.

Gnocchi

Serves 6

generous 2 pounds floury potatoes; 1³/₄ cups flour, plus extra for dusting; 1 egg; 1 tablespoon extra-virgin olive oil; freshly ground black pepper

Peel the potatoes and boil in salted water. Cooking time depends on variety and quality. As soon as they are tender, drain and run through a vegetable mill or potato ricer on a fine setting. Blend the flour into the still-hot pulp little by little, beating vigorously with a wooden spoon. Lightly whisk the egg and add it and the olive oil to the potato purée. Mix thoroughly, cover with a kitchen towel, and set aside for about 30 minutes.

Uncover the dough and, using a tablespoon, carve out small balls of the mixture. On a floured work surface, roll each ball into a shape as thick as a finger. Cut into sections 1¹/₄ inches long.

Place each section on your thumb and press it lightly with the tines of a fork, forming an indentation with your thumb. Place the gnocchi on a towel-covered tray. Set aside for another 30 minutes.

Plunge the gnocchi into a large volume of salted boiling water and, when they rise to the surface, remove them with a skimmer and drain. Place in a deep serving dish and top with freshly ground pepper.

Note: Gnocchi are a perfect accompaniment for Provençal stew (see recipe page 169), but you may also top them with meat drippings, tomato sauce, or freshly grated Parmesan cheese and melted, salted butter.

Niçois ravioli.

Niçois ravioli

Serves 6

DOUGH: 4 cups flour, plus extra for dusting; 3 eggs; 1 tablespoon olive oil; a pinch salt; 2/3 cup lukewarm water

FILLING: generous 2 pounds Chinese cabbage (Napa cabbage); 1 pound Provençal stew leftovers (or leftovers from a veal, pork, or poultry roast); 2 eggs; salt; freshly ground black pepper; freshly grated nutmeg

Measure the flour into a large bowl. Stir in the eggs, olive oil, and a pinch of salt. Knead, gradually adding the water until the dough no longer sticks to your fingers. Gather up the dough (it should still be a bit lumpy) into ball, and wrap in a lightly moistened kitchen towel. Refrigerate for at least 45 minutes.

Meanwhile, prepare the stuffing. Detach the green leaves from the white ribs of the Chinese cabbage. Reserve the ribs for another recipe. Plunge the green leaves into salted boiling water for 4 minutes. Drain and press thoroughly to eliminate the water. Finely chop the Chinese cabbage leaves and place in a large bowl. Finely chop the meat and vegetables from the leftovers. Add to the Chinese cabbage leaves. Whisk the eggs and add them to the bowl. Season with salt, freshly ground pepper, and grated nutmeg. Moisten with a little stew liquid, red wine, or broth.

Remove the ball of dough from the refrigerator and cut into slices about 1 inch thick. Flour a rolling pin and the work surface. Piece by piece, roll out the dough until it is no more than 1/4 inch thick. Cover the pieces with a moist towel as you roll the others.

Slice the strips of dough in half lengthwise. Run them through a pasta mill set on position 1 (cylinders wide apart). Fold each strip of dough in 3 like a letter, then run through the mill again. Repeat this operation until the dough is smooth (flour the mill's cylinders occasionally so the dough does not stick to them).

Set the mill's cylinders to position 2 and pass each strip of dough through. Place the strips on a large floured tray and cover with a moist towel.

Place two strips of dough side by side on the floured work surface and trim the edges equal with a pastry cutter. On one of the rolled-out pastries, use a teaspoon to place small piles of *pessuge* (prepared ravioli filling) in rows 1 inch apart. Brush the space between the rows with water. Place the second pastry over the first, then press down with a ruler or the handle of a wooden spoon between each row to solidly join the two pieces of dough. Cut out the ravioli using the pastry cutter.

Sprinkle the ravioli with flour and set aside on a towel. Repeat with the remaining pastry. The ravioli may not be made more than a few hours in advance.

Plunge the ravioli into a large volume of salted boiling water. They are done after about 3 or 4 minutes when they rise to the surface. Drain and place in a bowl. Top with a little stew sauce and a dash of olive oil. Serve immediately with a small cup of freshly grated Parmesan cheese.

Note: If leftover stew is not available, prepare the leftover meat of your choice with thyme, garlic, and diced, sautéed onions, then proceed according to the recipe.

Desserts

Orange charlotte with Menton lemon

Serves 6

⅓ cup confectioners' sugar; 10 tablespoons butter, at room temperature; 3 eggs; 1 cup crème fraîche; juice and zest of 1 unwaxed orange; juice and zest of 1 unwaxed lemon; 3 tablespoons walnuts; salt; 30 lady fingers; ¾ cup rum

In a large bowl, beat the sugar into the butter until creamy. Separate the eggs. Beat the yolks in a large bowl, then blend in the crème fraîche. Mix thoroughly before adding the butter mixture.

Plunge the orange and lemon zest into boiling water for a few seconds. Drain and finely chop. In the blender, reduce the walnuts to a powder. Blend the zests, the citrus juice, and the powdered walnuts into the cream. Mix thoroughly.

Beat the egg whites until stiff, adding a scant pinch of salt. Fold delicately into the cream.

Line a charlotte mold with plastic wrap (to ease removal). Cut the ends of the lady fingers into points so they form a rosette shape in the bottom of the mold. Line the bottom and edges of the mold with the lady fingers. Sprinkle with rum. Spread with half the cream, then cover with a layer of lady fingers. Sprinkle with more rum. Spread with the rest of the cream and finish with a last layer of lady fingers. Sprinkle again with rum. Settle the charlotte by tapping the mold on the work surface. Cover with plastic wrap and place in the freezer for 45 minutes, then refrigerate until serving. To serve, invert the mold over a serving dish and remove the plastic wrap. Decorate with orange slices and peeled lemon slices.

Roasted pineapple with cinnamon

Serves 6

3 small, ripe Victoria pineapples; ⅔ cup spiced rum; ½ cup brown sugar; 1 teaspoon cinnamon

Preheat the oven to 400°F. Place the pineapples, whole and unpeeled, on a baking sheet with sides. Protect their tops from burning by wrapping them in aluminum foil. Bake for approximately 1 hour, turning them after 30 minutes.

Remove from the oven and cut the entire pineapples in half lengthwise, carefully collecting the juice. Replace the pineapple halves on the baking sheet.

Heat the rum in a small saucepan. Pour the rum over the pineapples and carefully light with a match. Allow the flame to burn out.

Adjust the oven to broil. In a large bowl, combine the brown sugar with the cinnamon. Sprinkle this mixture over the hot pineapples and sprinkle with any reserved pineapple juice. Place under the broiler until the sugar has caramelized. Serve hot.

Note: Small Victoria pineapples, which are extremely sweet, have no central core and should be eaten entirely.

OPPOSITE: *Roasted pineapple with cinnamon.*

with a triple stainless steel bottom (copper jam preserving pans are too large for the quantity of fruit in this recipe). Add the zest to the watermelon pulp. Simmer over low heat for 1 hour, stirring occasionally. To test, cool a bit of jam and touch it with your fingers. It is done when sticky.

Peel the oranges and break them into quarters. Place in a large bowl and cover with hot water. Soak for 3 minutes, then drain. Section and seed the oranges.

Place $2^{1}/_{4}$ pounds orange sections in a second stockpot. Add the sugar, the zest, and 2 glasses water. Let the sugar completely melt before setting over medium heat. Bring to a boil and simmer for 1 hour.

Pour the watermelon jam into the orange jam and gently blend the fruit together. Bring to a boil and simmer for another 10 minutes.

Scald 6 jam jars and their screw-on lids for 3 minutes. Remove from the boiling water with a wooden spoon and invert on a kitchen towel to dry.

When the jam is ready, reduce the heat to a minimum. Using a glove, hold a jar over the pot and ladle the jam into the jar. Fill to the rim. Set the jar down and immediately screw on the lid. Turn the jar over to form a vacuum. Wipe the jars clean and label them.

Watermelon and orange jam
Makes 5 to 6 jars

For $2^{1}/_{4}$ pounds watermelon pulp: $2^{1}/_{2}$ cups granulated sugar; zest of $^{1}/_{2}$ lemon

For $2^{1}/_{4}$ pounds orange sections (buy at least 3 pounds whole oranges): $3^{1}/_{3}$ cups granulated sugar; zest of $^{1}/_{2}$ lemon

Cut the watermelon into slices, then carefully remove seeds and rind. Cut the pulp into pieces to obtain about $2^{1}/_{4}$ pounds. Place in a large bowl and cover with the sugar, letting the sugar melt entirely (it will take approximately 2 hours).

Pour the mixture into a stockpot or large saucepan

Saint Honoré
Serves 8

DOUGH: $^{3}/_{4}$ cup flour; 1 teaspoon superfine sugar; a pinch salt; 9 tablespoons butter, at room temperature; 1 egg; 1 tablespoon milk

CHOUX PASTRY: 1 cup mixed milk and water; 1 tablespoon superfine sugar; 1 tablespoon salt; 9 tablespoons butter; $^{3}/_{4}$ cup flour; 5 eggs; confectioners' sugar for dusting

CREAM: 2 tablespoons cornstarch; $1^{1}/_{3}$ cups whole milk; $^{1}/_{2}$ vanilla bean; 2 tablespoons superfine sugar; 5 egg yolks; 1 tablespoon butter

MERINGUE: 4 egg whites; scant $^{1}/_{2}$ cup superfine sugar

CARAMEL: 1 cup sugar; lemon juice

Prepare the dough. Sift the flour into a large bowl. Make a well in its center. Sprinkle in the sugar and salt. Add the softened butter in small pieces, the egg, and the milk. Mix together quickly, then gather the dough into a ball. Knead it twice with the palm of your hand. Reshape into a ball and wrap in plastic wrap. Refrigerate for 2 hours.

Roll the dough into a circle approximately 10 inches in diameter and trim the edges round. Prick the entire surface of the dough with a fork. Place the dough on a baking sheet lined with parchment paper. Refrigerate for 30 minutes.

Meanwhile, prepare the choux pastry. Combine the water-and-milk mixture in a saucepan with the sugar, salt, and butter. Bring to a boil over low heat. Remove from the heat and add the flour, mixing vigorously. Return to the heat and stir the dough until it no longer sticks to the edges of the pan. Fold in 2 eggs, whisk for 1 minute, then add the 2 other eggs, whisk, and finally, whisk in the last egg. Beat the dough until smooth. Pour it into a piping-bag fitted only with the inner socket ($^3/_4$ inch in diameter).

Preheat the oven to 400°F. Remove the baking sheet from the refrigerator. Moisten the edge of the dough with a pastry brush dipped in water. Using the piping-bag filled with the choux pastry, make a broad border on the moistened edge. With the rest of the choux pastry, make 16 small balls on the surrounding parchment. Sprinkle the balls and the choux pastry border with sifted confectioners' sugar. Bake for 15 minutes, then reduce the heat to 350°F and bake for another 10 or 15 minutes. Keep a close eye on the pastry and remove from the oven as soon as the choux puffs are firm. Cool on a cooling rack.

Now prepare the cream. In a saucepan, make a paste with the cornstarch and a little of the milk. Scrape the seeds from the vanilla bean into the saucepan, and add 1 tablespoon sugar. Pour in the milk and whisk thoroughly. Bring to a boil over low heat, stir-ring constantly. In a large bowl, whisk the egg yolks with the remaining sugar until frothy. Slowly pour in the boiling milk, whisking vigorously. Pour the cream back into the pan and bring to a simmer over low heat, whisking constantly. Shave the butter onto the surface. Remove 6 heaping tablespoons of the cream and set aside. Place the pan with the cream into a double-boiler so that it remains very hot.

For the meringue, combine the sugar with 2 table-spoons water in a small saucepan. Bring to a rolling boil and test by removing a small tablespoon of sugar and dropping it into a large bowl of cold water: it should form a ball. Whisk the egg whites into stiff peaks, adding 1 teaspoon sugar when almost stiff. Pour the boiling sugar into the egg whites between the wall of the bowl and the whisk. Whisk until the sugar is thoroughly mixed with the whites. Pour the hot cream from the double-boiler over the whites and blend gently but quickly.

Make a slit in the base of the 16 pastries with a knife tip. Put the reserved cream into a piping-bag fitted with a $^1/_4$-inch tip and fill the pastries with the cream.

Now prepare the caramel. Pour the sugar into a saucepan. Add 4 tablespoons water and a few drops lemon juice. Stir over medium heat until the caramel is golden. Remove from the heat. Delicately dip the top of each filled pastry into the caramel. Then return to the parchment. When the caramel is cold, arrange the pastries in a circle around the choux pastry border, attaching them with a drop of caramel.

Top each pastry puff with the cream. It can be smoothed with a spatula, or piped with a fluted tip to form large, beautiful rosettes. Refrigerate until serving. Serve the same day.

Note: The pastries may instead be topped with whipped cream with a dash of kirsch.

Crème brûlée with Tahitian vanilla

Serves 6

1 cup whole milk; 3 cups heavy cream; 3 Tahitian vanilla beans; 7 egg yolks; generous ³/₄ cup sugar; brown sugar

Combine the milk and cream in a saucepan. Split the vanilla beans in half lengthwise and scrape their seeds into the milk mixture. Add the beans and bring to a boil over low heat. Remove from the heat and set aside to infuse.

Whisk the egg yolks with the sugar until thick. Remove the vanilla beans from the pan and scrape again, adding the flesh to the cream. Pour the eggs into the milk mixture, whisking constantly.

Preheat the oven to 300°F. Place 6 ramekins on a baking sheet with edges. Fill the ramekins with the cream. Pour a little water onto the sheet around the ramekins. Bake for 45 minutes.

Remove from the oven and let the cream cool completely, then cover with plastic wrap and refrigerate overnight. Remove from the refrigerator 1 hour before serving. Just before serving, sprinkle the tops with brown sugar and carmelize with a heated salamander or a kitchen blowtorch.

Note: If you don't have a salamander or a blowtorch, carefully singe the top of the cream under the broiler.

Teatime spongecake

Serves 6

2 sticks plus 2 tablespoons butter, at room temperature; 1 cup sugar; 1¹/₃ cup ground almonds; 6 eggs; ¹/₂ cup flour; 1¹/₂ cups rum; 2 tablespoons apricot jam; ³/₄ cup confectioners' sugar

Preheat the oven to 350°F.

In a large bowl, combine the butter and sugar. Blend with a wooden spoon until smooth. Blend in the ground almonds.

Beat the eggs in a large bowl with a fork. Gradually pour the eggs into the almond mixture, stirring constantly. When the batter is thoroughly blended, add the flour and mix, but do not overwork. Mix in ¹/₂ cup rum.

Butter and flour a deep cake pan 9 inches in diameter. Pour in the batter and bake for 45 minutes.

Remove the cake from the oven and invert onto a cooling rack. Baste the cake with ¹/₂ cup rum.

In a small bowl, dilute the apricot jam in a little hot water. Pass it through a sieve, then baste the cooled cake with it. Beat the confectioners' sugar with the remaining rum in a large bowl. Using a spatula, coat the top and edges of the cake with the icing.

When the icing has set, carefully place the cake on a serving dish.

Crème brûlée with Tahitian vanilla.

Peaches in sweet wine

Serves 6

12 white peaches; 1 bottle (750ml) Banyuls wine (or Muscat, Sauternes, or Italian vin santo); 3 tablespoons superfine sugar; 12 blanched almonds

Fill a large bowl with crushed ice cubes and water. Make a small X-shaped incision in the bottom of each peach. Plunge the peaches into boiling water for a few seconds. Remove them immediately with a slotted spoon or skimmer and place in the cold water. Drain. Remove the skins and set the skins aside. Cut the peaches in half and remove the pits. Cut each half in half again.

Combine the sweet wine and the sugar in a saucepan. Bring gently to a boil, then add the peach skins. Simmer for 5 minutes, then remove the skins with a slotted spoon or skimmer. Add the peach quarters and the almonds to the boiling wine. Return to a boil, and immediately remove from the heat. Cover and cool. Pour the peaches, almonds, and juice into a large bowl and macerate, covered, in the refrigerator for 2 or 3 hours. Serve cold.

Peach Melba

Serves 6

6 very ripe peaches; 3/4 cup superfine sugar; 1/2 pound red raspberries; 1 pint vanilla ice cream; 1/2 cup slivered almonds

Fill a large bowl with crushed ice cubes and water. Plunge the whole peaches into boiling water for 2 seconds. Remove with a slotted spoon or skimmer and place in the cold water. Peel and halve the peaches, and pit them. Place them in a dish and sprinkle lightly with 2 tablespoons sugar. Cover with plastic wrap and refrigerate.

Run the raspberries through a vegetable mill or a fine sieve. Combine the raspberry purée with the remaining sugar, then cover and refrigerate.

Just before serving, scoop 2 spoonfuls vanilla ice cream into each of 6 individual cups. Top each with 2 cold peach halves and a spoonful of raspberry purée. Sprinkle with the slivered almonds. Serve immediately.

Note: The original Peach Melba recipe was created by the chef Auguste Escoffier in 1899 in homage to the diva Dame Nellie Melba. The success of Escoffier's creation was immediate, but much to his disappointment, the recipe was often altered. As Escoffier was to write: "A Peach Melba is made up of tender, very ripe peaches, vanilla ice cream, and sweetened raspberry purée. Any exception to this would blemish the finesse of this dessert. Some allow themselves the liberty of replacing the raspberry purée with strawberries or currant jelly, or decorating the Peach Melba with whipped cream. But in so doing, they come no nearer to its real flavor."

OPPOSITE: *Peaches in sweet wine.*

Provençal watermelon

Serves 6

1 large, very ripe watermelon; 5 to 6 tablespoons lavender honey; freshly ground black pepper; 1 bottle (750 ml) rosé wine; mixed berries for garnish

Cut off the top third of the watermelon and place its lid aside. Slice just a thin piece of rind off the bottom so it stands upright. Using a large spoon, remove the pulp from the melon and lid, and discard the seeds. Cut the pulp into small, irregular pieces. Place in a large bowl. Drizzle with the honey and sprinkle with freshly ground pepper. Pour all the pulp back inside the hollowed watermelon. Place the watermelon in a bucket filled with ice cubes. Pour the rosé wine into the watermelon. Mix thoroughly and replace the lid. Let the contents macerate for 2 hours, adding ice cubes to the bucket as needed. Serve with a ladle, pouring the wine and pulp into frosted glasses, and garnish with berries.

Panellets

Makes about 15

1 pound whole blanched almonds, toasted; 1²/₃ cups superfine sugar; 4 egg whites; 1 cup pine nuts

Preheat the oven to 475°F. Coarsely chop the almonds. In a large bowl, combine the almonds with the sugar. In another large bowl, whisk the egg whites lightly with a fork until they just start to froth. Pour the egg whites over the almonds and sugar and mix thoroughly.

Put the pine nuts on a plate. Make balls of dough about the size of quail eggs. Roll each ball in the pine nuts, pressing down lightly so they stick to the dough.

Generously butter a baking sheet. Place the panellets on the sheet and bake for 15 to 20 minutes. The panellets should be golden brown. Remove from the oven and cool on a cooling rack. Enjoy immediately (the fresher the better) with Peaches in sweet wine or with Crème brûlée with Tahitian vanilla.

Vatrouchka

Serves 6 to 8

DOUGH: 1²/₃ cups flour; ¹/₂ packet active dry yeast; ³/₄ cup (1¹/₂ sticks) margarine or vegetable shortening; 1 egg yolk; juice of ¹/₂ lemon; 1 teaspoon butter

CREAM: 1 egg plus 2 yolks; 1 cup superfine sugar; 1²/₃ pounds fromage blanc, drained in a strainer until completely dry; 4 ounces mixed candied fruit, chopped; 2 packets vanilla sugar

In a large bowl, combine the flour with the yeast. Cut the margarine into small pieces and work into the flour. Add the egg yolk and the lemon juice and combine. Knead briefly, then gather the dough into a ball. Flatten the ball of dough, cover with a kitchen towel, and refrigerate for 1 hour.

Butter a 13 x 9 x 3-inch baking pan. Place the ball of dough in the center of the pan and press the dough onto the bottom and up the sides of the pan. Place the pan in the refrigerator.

Preheat the oven to 475°F. In a large bowl, whisk the egg and yolks together with the sugar until thick. Blend in the drained fromage blanc, the candied fruit, and the vanilla sugar. Mix thoroughly, then pour the cream into the dough. Level the surface with a spatula. Bake for 20 minutes. Reduce the heat to 400°F and bake for another 20 minutes. Remove from the oven and cool completely before cutting into slices or large squares.

Note: Fromage blanc is a soft white cheese available at Russian groceries; whole-milk ricotta can be substituted in a pinch.

Brown sugar pie

Serves 6

DOUGH: 1 cup (2 sticks) butter; 1 packet (1/4 ounce) active dry or fresh compressed yeast; 1/4 cup milk; 1 2/3 cups flour; 1 teaspoon sugar; 1 teaspoon salt; 3 eggs

FILLING: 3/4 cup packed light brown sugar; 2 tablespoons light cream or whole milk, lukewarm; 1 egg yolk; 2 tablespoons butter, plus extra for greasing

Soften the butter. In a small bowl, dissolve the yeast in the milk. Sift the flour into a large bowl. Make a well in the center and add the butter in lumps. Sprinkle in the sugar and salt. Break the eggs into the well. Combine the wet ingredients and begin to draw in the flour. Add the milk mixture and knead together. The dough is ready when it no longer sticks to your hands. Cover the dough with a kitchen towel and set aside at room temperature to double in volume.

Preheat the oven to 350°F. Butter an 8-inch tart pan. On a floured work surface, roll the dough into a circle. Transfer the dough to the pan. Cover with a towel and set aside for 1 or 2 hours to double in volume.

Sprinkle the dough evenly with the brown sugar, leaving a 1/2-inch border on the edges. In a small bowl, mix the cream and the egg yolk thoroughly. Using your fingertips or a spoon, sprinkle the sugar with the cream mixture. Place thin slices of butter over the sugar.

Bake for 25 minutes. Remove from the oven and remove the tart from the pan. Cool on a cooling rack. This sugary pie is delicious warm.

Brown sugar pie.

Purple fig tart

Serves 6

2 pounds very ripe purple figs; 2 tablespoons quince jelly

DOUGH: 7 tablespoons butter, plus extra for greasing; 3 tablespoons confectioners' sugar; 2 tablespoons ground almonds; 1/2 vanilla bean; 1 cup flour; pinch salt; 1 egg

CREAM: 2 tablespoons cornstarch; 1 cup whole milk; 3 tablespoons sugar; 1/2 vanilla bean; 3 egg yolks; 1 tablespoon butter

Prepare the dough the night before. Bring the butter to room temperature in a large bowl. Sift the confectioners' sugar onto the butter. Add the powdered almonds and scrape the seeds from the vanilla bean into the bowl. Sift in the flour. Add the salt and the egg. Quickly combine all the ingredients with your fingers, then gather the dough into a ball. Flatten into a disk. Wrap in plastic wrap and refrigerate overnight.

The next day, let the dough soften at room temperature. Butter a 10-inch tart pan. Place the flattened dough in the pan and press the dough into the pan and up the sides. Trim the edges. Prick the bottom several times with a fork. Refrigerate for 1 hour.

Meanwhile, prepare the cream. In a saucepan, make a paste with the cornstarch and a little of the milk. Add half the sugar. Scrape the seeds from the va-nilla bean, and add the seeds and the bean to the pan. Pour in the milk and whisk thoroughly. Bring to a boil over low heat, whisking constantly. In a large bowl, beat the egg yolks with the remaining sugar until creamy. Gradually pour the boiling milk on top, whisking vigorously. Remove the vanilla bean. Pour the cream back into the saucepan and bring to a simmer over low heat, whisking constantly. Remove from the heat and immerse the bottom of the pan in a large bowl of ice-cold water. Dab the surface of the cream with thin slices of butter. Set aside to cool.

Preheat the oven to 350°F. Cut out a circle of grease-proof paper the same size as the pan. Place it over the dough and fill the pan with dried beans. Bake for 10 minutes. Remove the paper and beans and bake for another 10 minutes. Remove from the oven. Re-move the tart from the pan and cool on a cooling rack.

Wash and dry the figs. Split 1 fig into a star shape. Remove the bottoms and stems from the rest of the figs. Cut into rounds, then halve. Spread the cooled cream in the tart shell. Arrange the fig slices in concentric circles on the cream. Place the star-shaped fig in the center. Slowly melt the quince jelly in a saucepan. Brush the jelly over the figs. Serve.

Note: The cream may be flavored with 1 or 2 tablespoons good kirsch or eau-de-vie.

OPPOSITE: *Purple fig tart.*

Acknowledgments

I should like to thank in particular Mr. Claude Duthuit—who gave in to my demands and without whom this book could never have been written—as well as Wanda de Guébriant, who aided me with her advice.

Additional thanks goes to Mr. Xavier Girard, curator of the Musée Matisse in Nice, Mr. Christian Arthaud, Mr. Lotigié of the Cultural Department of the City of Nice, Mrs. Violette Véran, Mrs. Malaussena, Mr. Wursthorn, Michelle Badrud, Michel Léger, Sabine Dauré, and to François and Anne de Constantin who all brought me their help and support.

JEAN-BERNARD NAUDIN

We were very touched by the availability of the antique dealers Cécile Maupin, the Maison Comoglio, the City of Mogador, and the Bassali gallery, who showed the greatest enthusiasm for our project. We are deeply grateful for their assistance.

A large thank you to all the persons and organizations who gave us their trust and made freely available to us various fabrics and objects: Trousselier, Émilio Robba, Muriel Grateau, Le Faucon, Le Puceron Chineur, Métaphores, Etro Arredamento, Beaumont & Fletcher, Baccarat, Canovas, Conran Shop, Étamine, Bisson Bruneel, C.S.A.O., Le Jardin Moghol, Laure Welfling, Au Débotté, Asiatides, Mise en Demeure, Les Milles Feuilles, and Baptiste for Liliane François.

Special thanks to Cécile Armagnac, Patrice Nourissat, Michèle Tronel and Patricia Donato who opened their closet doors for us.

This book gave us the pleasure of meeting Maria-Françoise Houzon Bory who, with her flawless knowledge of Nice, provided us with friendly and efficient assistance. We cordially thank her.

Thank you to Le Safari restaurant, who made the fig pie for us.

Last but not least, we had the greatest pleasure in working with our team of assistants: Delphine Pietri, Camille Poncin, and Mathieu Barret.

MARIE-CHRISTIANE NOURISSAT and CLAIRE DE LAVALLÉE

I should like to express my deep recognition and my warm gratitude to all those who helped me in my work: Geneviève Baudon, the Librairie Gourmande, Véra Olovianichnikoff, Georges and Nicolas Korsakoff, Jacques and Gérard Giaume, Fabrice Subiros, Philippe Hornez, Siècle, Art Domestique Ancien, Éric Dubois, and the Musée Escoffier.

COCO JOBARD

GILLES PLAZY thanks Mme Hansma, of Éditions Irus et Hansma, for her assistance.

The Éditions du Chêne thank the Laboratoire Gorne
for their kind collaboration in film development.

Index of Recipes

Index of Works

Bibliography

(Where available, English editions are listed in place of the French.)

————. Catalog, *Henri Matisse, 1904–1917*. Paris: Musée National d'Art Moderne, February 23–June 1993.

Correspondance Matisse-Camoin, published by Danièle Giraudy, *Revue de l'Art*, n°12, 1971.

Apollinaire, Guillaume. *Oeuvres complètes en prose*. Paris: Pléïade.

Aragon, Louis. *Henri Matisse*. Paris: Gallimard, 1971.

Bonnard, Pierre and Henri Matisse. *Correspondance*. Paris: Gallimard, 1991.

Carco, Francis. *L'Ami des peintres*. Paris: Gallimard, 1953.

Courthion, Pierre. *Le Visage de Matisse*. Lausanne: Marguerat, 1952.

Delectorskaya, Lydia. *Henri Matisse, Contre vents et marées*. Paris: Irus and Vincent Hansma, 1996.

————. *Henri Matisse, . . . l'apparente facilité. . . .* Paris: Adrien Maeght, 1986.

Diehl, Gaston. *Henri Matisse*. Paris: Nouvelles Éditions Françaises, 1970.

Escholier, Raymond. *Matisse, ce vivant*. Paris: Arthème Fayard, 1956.

Gilot, Françoise. *Matisse & Picasso*. New York: Doubleday, 1992.

Matisse, Henri. *Écrits et propos sur l'art*. Paris: Hermann, 1989.

Pleynet, Marcelyn. *Henri Matisse, Qui êtes-vous?* Lyon: La Manufacture, 1988.

Schneider, Pierre. *Matisse*. New York: Rizzoli, 1984.

Stein, Gertrude. *The Autobiography of Alice B. Toklas*. New York: Random House, 1993.

Verdet, André. *Entretiens, notes et écrits sur la peinture*. Paris: Galiliée, 1978.

Photography Credits

First published in the United States of America in 1998 by
RIZZOLI INTERNATIONAL PUBLICATIONS, INC.
300 Park Avenue South, New York, NY 10010

First published in France in 1997 by
Éditions du Chêne-Hachette Livre

ISBN 0-8478-2088-2
LC 97-76389

Chief Editor: Philippe Pierrelée
Managing Editor: Cécile Aoustin
Art Editor: Sabine Büchsenshütz
Text Translator: 3IC International (France)

Separations by Offset Publicité, Maisons-Alfort

Printed in Italy by Canale, Turin